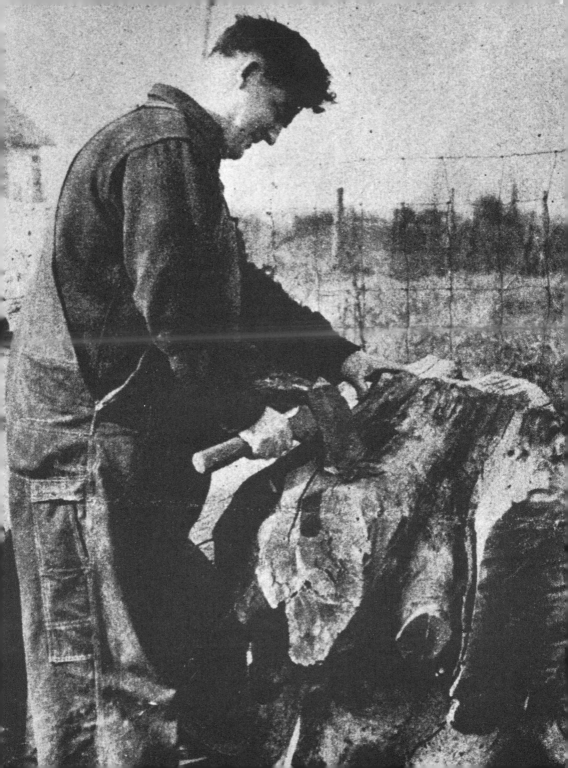

Fred E. Myers
WOOD-CARVER

By Richard A. Lawson and George J. Mavigliano

SOUTHERN ILLINOIS UNIVERSITY PRESS
Carbondale and Edwardsville

FEFFER & SIMONS, INC.
London and Amsterdam

Frontispiece: Fred Myers working on a walnut stump. Photograph by C. William Horrell of the Department of Cinema and Photography, Southern Illinois University at Carbondale. The print appeared in the *St. Louis Post-Dispatch*, April 20, 1941, and is reproduced by permission of the newspaper and the photographer.

Printed in the United States of America

Designed by Robert L. Nance

Library of Congress Cataloging in Publication Data

Lawson, Richard A
 Fred E. Myers, wood-carver.
 Bibliography: p.
 Includes index.
 1. Myers, Fred E., 1910–1950. 2. Wood-carver—
Illinois—Biography. I. Mavigliano, George J.,
1941– joint author. II. Title.
NK9798.M9L38 730'.092'4 [B] 80-14243
ISBN 0-8093-0974-2

To all those friends of Fred
who never "quit remembering" him
and who opened their homes and hearts to us

Contents

List of Illustrations

Preface

It is a great joy when an artist, heretofore unknown, is brought to the attention of a new age. Fred E. Myers is a case in point. A coal miner turned wood-carver during the 1930s, his work was known primarily on a local level. Death came in 1950 at the age of thirty-nine, yet an oeuvre remains of over one hundred pieces that attest to his artistic ability. This book records the major events in Myers's brief life, and attempts to place his wood carvings into an art historical perspective.

During a question and answer session following a lecture on Myers's life and art, given at Southern Illinois University at Carbondale, a professor asked how we could possibly be singing the praises of Myers when back in the late thirties and the forties the Department of Art did not think much of his sculpture? The answer may have been less than adequate. It had something to do with changing American tastes, and that anything associated with the federal government was never considered seriously as art.

The question proved bothersome. After some thought, a better answer emerged. When the subject of Myers's chisel was local and familiar, his work transcended the ordinary. His subject matter became fresh and original, and reminiscent of the regionalist mode that pervaded the Midwest during the 1930s.

The Great Depression of the thirties reached across the country and into the rural areas of southern Illinois. The major industry was coal and the mines were rapidly closing. Large numbers of men were unem-

ployed. Though Myers always thought of himself as a coal miner, the opportunity to work for the federal government allowed him to turn, full-time, to carving, and provided valuable income for the family. The Works Progress Administration (later designated Work Projects Administration) was criticized by many during this time. It came to be known as "We Piddle Around." This was unfortunate, since the WPA was instituted to put people to work so that they could maintain their self-respect. It seemed far better to be "piddling" around than idly standing by filled with despair.

The years from 1929 to 1941 created great trauma in the United States, but they must also be seen as fertile ones for Fred Myers. It seems strange to say it, but without the depression and the WPA, three of Myers's most creative and productive years, 1939 to 1942, would never have occurred.

It is hoped that the cataloging of Fred Myers's carvings will create not only a well deserved place for him in the history of American art, but will also identify as many carvings as possible. This is imperative since many have been scattered across the country, and others have been either lost or carelessly destroyed.

An in-depth biography should have been undertaken years ago, but it is particularly important now since many of the friends who knew Fred well are getting on in years or have already passed away. In a few years that enormous resource of oral history will be lost. We would particularly like to thank Raymond Myers, Fred's brother, for the opportunity and help he gave us in searching through family records. To Harold Mitchell, Frank and Louis Tresso, Jack Batts and especially Geno Casagrande, we would like to extend our heartfelt thanks. To the other people who responded to our inquiries and shared whatever knowledge they had of Fred, we thank you all.

Our work on the life and art of Fred Myers has taken two intensely packed years of research. We feel we now know as much about Fred as anyone—maybe more. And yet, despite this knowledge, we never had the pleasure of meeting Fred or sharing his humor or his friendship. No amount of research can fill that void. We envy those who knew him as a

friend. Nonetheless, we have tried, in the following pages, to present an accurate and honest portrait of the man and his art.

The authors wish to express their appreciation to the many people who generously contributed so much information about Fred E. Myers. This book would not have been possible without their assistance. In alphabetical order: Minnie Amati, Thomas F. Barton, Jack Batts, Werner Beldo, Mary Ann Bianchi, Ina Bruce, Clarence Cagle, Josephine Cagle, Mr. and Mrs. Geno Casagrande, Lendell Cockrum, Frank Cornia, John Deason, Howard Deason, Walter Drake, Margaret Fortune, Dr. Benjamin Fox, Peryl Galloway, Willard Gersbacher, Mrs. Mike Golio, George Hall, Rose Pesula Hand, Irene Killian, Edward Kownacki, Kenneth Lazzeri, John Marchand, Marjorie Martin, Moreau Maxwell, Bruce Merwin, Don Mitchell, Gilbert Roy Mitchell, Harold Mitchell, Ralph Murray, Raymond Myers, William Myers, William Palmer, Evan Paper, Gus Peebles, Irvin Peithman, Victor Randolph, Joe Restivo, Louis Ruzich, Harry Scroggins, Mr. and Mrs. Al Steyer, Harry Surgalski, Julius Swayne, Charles Tezzoni, Joe Tolluto, Mr. and Mrs. Fred Tregoning, Mr. and Mrs. Frank Tresso, Mr. and Mrs. Louis Tresso, K. A. VanLente, Marian Warren, Wanda Franklin Williams, John Wright, Lacy Wright, Felicia Amati Young, and Otis Young.

We are also indebted to the following for assistance in researching Fred E. Myers: Jane Crichton; the Detroit Institute of Art, WPA Archives; Field Enterprises, Inc., Tom Ray; Frankfort Area Historical Museum, Gladys Koehl and Mavis Wright; the Franklin County Court House of Benton, Illinois; the *Southern Illinoisan*, Ben Gelman; the Illinois State Museum, Robert Evans and Basil Hedrick; the Jefferson County Court House of Mount Vernon, Illinois; the Jefferson Memorial Hospital of Mount Vernon, Illinois; KFVS-TV of Cape Girardeau, Missouri; Virginia Marmaduke; Betty Allen Miller; the Modert Clinic of Mount Vernon; The St. Louis Art Museum; the *St. Louis Post-Dispatch*, Gene Pocpeshil; Southern Illinois University at Carbondale Alumni Office; the Morris Library, Southern Illinois University at Carbondale, and David Koch and John Clifford; Southern Illinois University at Carbondale, University Museum and Art Galleries, John Whitlock, Evert

Johnson, and William Johnson; the Union Hospital of West Frankfort, Illinois; WPSD-TV of Paducah, Kentucky; WSIU-TV, George Korn's "Good Company"; and the West Frankfort *Daily American*.

We are indebted to the following for research, logistical and financial support: the Department of Art, Milton Sullivan; the College of Communication and Fine Arts, C. B. Hunt; the College of Liberal Arts, Lon Shelby and Worthen Hunsaker; the Department of English, Robert Partlow and William Simeone; George McClure for the Illinois Humanities Council; and the Office of Research Development Administration, Michael Dingerson. Jim Sullivan and Steve Tietz assisted with the manuscript, and Jack Holderfield, C. William Horrell, and Dan Tetzlaff assisted with the photographs. Photographs, unless otherwise noted, are by Richard A. Lawson.

We especially acknowledge the cheerful, hard-working, dedicated assistance of Pauline Duke, Rachel Lorton, and Catherine Shorter of the Department of English staff for transcribing the taped interviews and for manuscript preparation.

Finally, we wish to express our gratitude to our wives Carole and Renée who endured the long hours we spent on this research and who sustained us through marathon photographic printing sessions and manuscript preparation.

Richard A. Lawson
George J. Mavigliano

Carbondale, Illinois
January 28, 1980

Fred E. Myers
WOOD-CARVER

*Where Fred is concerned, my memory is pretty good
because I never did quit remembering about Fred.
I practiced remembering. Because, as you can see why,
I never got over feeling a great loss that
Fred was not with us anymore.*
JACK BATTS, 1979

LIFE

Somehow he looked different lying there. He wasn't wearing his bib overalls. A brown pair of pants was found to fit him, and he wore a white shirt opened at the collar. Fred liked to joke that he didn't want to be buried in a tie because he didn't want to choke to death. The body was laid out in the living room of the Myerses' Waltonville home, which was typical practice for southern Illinois at that time. The neighbors came in and paid their respects and sat around. A few close friends sent flowers.

Fred's mother walked over to the casket and stood there looking down at Fred. She reached over and rubbed the top of his large calloused hands that were clasped together on his chest. Fred always had big callouses where he'd hold his chisels. Turning around she walked back to her chair across the room. This sequence of events occurred frequently through the night and following day. As Jack Batts recalls:

> I think it was one of the greatest griefs I have ever seen, and the woman didn't shed a tear. . . . I sat over there and I may have been the only one in the room who realized what a great loss it was. . . . I thought about this and I realized that there are lots of mothers who will lose their children, and it is a great loss to them; but I kept wondering how great is the loss to this woman?[1]

The local Baptist minister came by to pay his respects out of sympathy for Mrs. Myers, for Fred was not a religious man. Later Raymond, Fred's

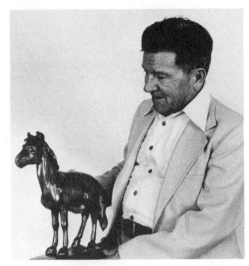

1. Jack Batts, January 16, 1979

3. Geno Casagrande, September 5, 1979

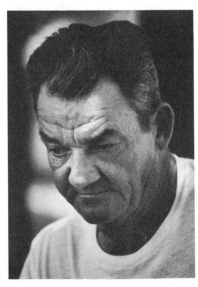

2. Raymond Myers, July 10, 1978

4

brother, recalls that he was somewhat surprised by Fred's subject matter on his earlier bark drawings, since the drawings were primarily religious in nature. Fred never talked about religion and the family did not attend church regularly. Geno Casagrande, a longtime friend, recalls Fred saying, "I don't want to talk about it, we're not going into that." And Geno would agree. Fred's mother always came first even before any supreme being. He felt that man should live each day, one at a time, and that one shouldn't blow everything in one day, that one should save something for tomorrow.

Many of Fred's friends who came to the house that night couldn't help but notice the unfinished figure of an Indian, barely emerging from the wood, sitting astride his horse. The figure rested on a table in a room Fred used as a studio in the Waltonville home. The *Last Stand*[2] was surrounded by other pieces that remained in Fred's possession. The *Grant on Horseback* was there, as well as *The Myers Lincoln*, the first major piece Fred carved back in 1929.

The Early Years, 1910–38

Fred Eric Myers's brief life began February 8, 1910, in Woodlawn, Illinois, in Jefferson County. Born to James Jonas Myers and Louana Bruce Myers, he was the first of two sons. Raymond Myers, the second son, was born six years later in Centralia Hospital on November 18, 1916. The Myerses owned a farm near Woodlawn, and, during the six years before Raymond's birth, Mr. Myers also worked on railroad construction in the Mount Vernon-Waltonville area. In 1917, shortly after Raymond's birth, the lure of work in the southern Illinois coal fields led the family to move to West Frankfort, Illinois, in Franklin County some forty miles away. Upon arriving in West Frankfort, Mr. Myers went to work in the Old West mine, while Mrs. Myers was busy raising the boys and homemaking. The family quickly settled in the area of the mine, first on Jones Street and later on Horn and Chestnut streets. They rented a series of

four houses from Mrs. Bruce, an aunt, during the eighteen years James and Fred worked for the mines.

These were pleasant years for Fred. Besides playing with his brother, he was a free spirit who enjoyed whittling, hunting, fishing, shooting marbles, and going barefoot. Very early on it appeared that Fred had some innate artistic talent. In addition to his whittling, he drew cartoons

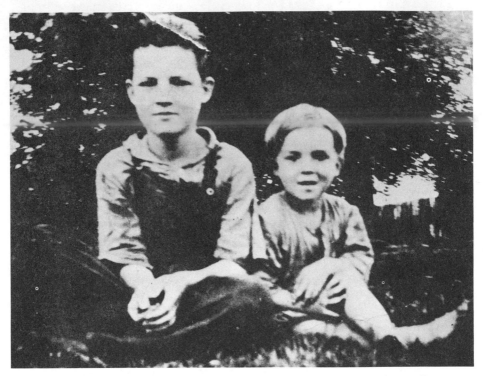

4. Left to right: Fred and Raymond Myers. Raymond and William Myers Collection, Litchfield Park, Arizona

on his friends' arms. His grade school teachers recognized his ability and encouraged him as much as possible. His talent appeared to have no antecedents, since Raymond does not remember any mention of artistic talent in the family.

Fred completed Edwards Grade School by the spring of 1924 and he spent the next two years attending West Frankfort High School. In 1926, when he was sixteen years old, he left school in order to work in the Old West mine. He wanted to continue his art education in painting and carving, but the family needed his salary.[3] Although these were the relatively carefree years of the 1920s, times were hard for the coal miners. Walter Drake, a close friend who also worked in the mines, remembers that one earned twenty-four dollars a month by working for six dollars a day, two days a week, and two weeks out of the month. Invariably, each summer the miners would go out on strike. There was a time when Fred's father worked as a motorcycle patrolman for the West Frankfort Police during the summers when he was not working for the mines.

Although Fred worked in other mines during the next twelve years, he stayed with his favorite working place, the Old West mine, through its many shutdowns, until it ceased operation in 1936. Another close friend, Louis Tresso, remembers that it was a good mine to work for with an excellent seam of coal and little danger of gas. In addition, Mr. Horn, one of the two owners of the mine, was compassionate and kind toward his workers. Those early mining years left their mark on Fred. Despite the fact that he spent considerable time away from the mines in later years, he always thought of himself as a coal miner.

His interest in serious carving came from those early years in the mine when he met a fellow coal miner who used to carve jigsaw puzzles in wood. This fascinated Fred, and he joined his new friend in carving them. Prior to the 1930s, Fred had also done bark carvings. Raymond Myers remembers that Fred created them on maple bark by stretching the bark and using a needle to scratch on it. When the bark dried, the scratches stood out in contrast to the rest of the bark. Fred continued his drawing when he was in the mine by doing cartoon chalk drawings of his friends on the coal cars and on the planking that held up the walls of the mine. Walter Drake remembers that the district supervisor, who had seen Fred's drawings, offered to set him up in a cartooning job with his son-in-law at the *Chicago Daily News*. Fred refused the job by simply saying, "How am I supposed to hunt squirrel in the big city?"[4] When the

Old West mine was closed, the shaft was filled up and numerous Myers drawings were lost. Fred also did some painting during this time, mainly landscapes. He painted the scenes on the back side of glass, which was then inserted into a frame with a backing added so that one looked through the glass to the scene. So far, only one painting, which is owned by the Steyer family of West Frankfort, is known to have survived. In addition, none of the jigsaw puzzles or bark carvings have been discovered.

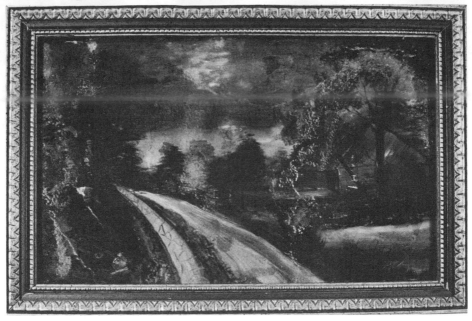

5. *Landscape* [Catalogue no. 8]

In 1929, when Fred was nineteen years old, the Great Depression hit southern Illinois. During the next ten years, while Fred was in his twenties, he kept up sporadic work in the mines. He brought in extra money by carving pistol stocks for the West Frankfort Police, thanks to his father's being on the force and due to Fred's growing reputation as a carver.

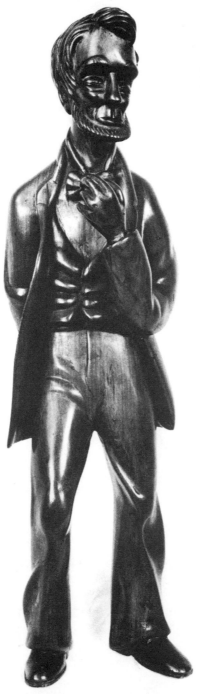

6. *The Myers Lincoln*
[Catalogue no. 1]. Front view

9

In 1929 Fred began work on the first of three major pieces. *The Myers Lincoln* was made from a railroad tie that he brought home one day from the mine. This piece was created with primitive tools—a hawkbill knife and pieces of glass for finishing. The use of glass was a traditional method of finishing wood carvings, but in Fred's case his family's lack of money demanded the use of it since sandpaper cost money. During 1933 to 1935 Fred carved a seated Lincoln (now known as *The Warren Lincoln*) reminiscent of the Lincoln Memorial in Washington, D.C. And during an eighteen-month period he carved his *Grant on Horseback*. Finally, a photograph has survived showing him, in front of the family's Model A Ford, holding a carving of a *Crow* that was inspired by a neighbor's pet.

Fred was also a regular at Pete Mondino's West Frankfort poolroom during this time. Mondino was a popular figure who had played baseball for the Saint Louis Cardinals and was managing a local semipro team. But he was revered more for the hunting dogs he trained. Fred carved two dogs for his friend Mondino. The first was a coonhound which didn't turn out the way they had planned (see ill. 82). Moreau Maxwell was later to buy the piece from Fred before he could destroy it. Maxwell worked on the WPA and became a close friend of Fred. When Mondino refused to buy the piece, Maxwell offered Fred thirty-five dollars.

A second carving was of Mondino's prized retriever *Pete's Doctor* which was lost after Mondino's untimely death, on June 3, 1967. A brass casting of the carving survives giving us some idea of what the piece looked like. No one remembers why the casting was done.

Fred never stopped drawing cartoons. He had grown from doing sketches on his young companions' arms to doing drawings for his friends on odds and ends of paper. On one occasion he drew pictures on a Vitalis advertising booklet which he did for his long-time friend Harold Mitchell. Many of these drawings were ribald and were freely sketched during pauses in a pool game at Mondino's.

Fred was, from everyone's point of view, a gentle, kind man. At the same time, his strength was legend. He wore bib overalls, preferably two sizes too big, to fill his six-foot, two-inch, 225-pound frame. As Robert Hastings states, bib overalls were "the standard Depression uniform."[5]

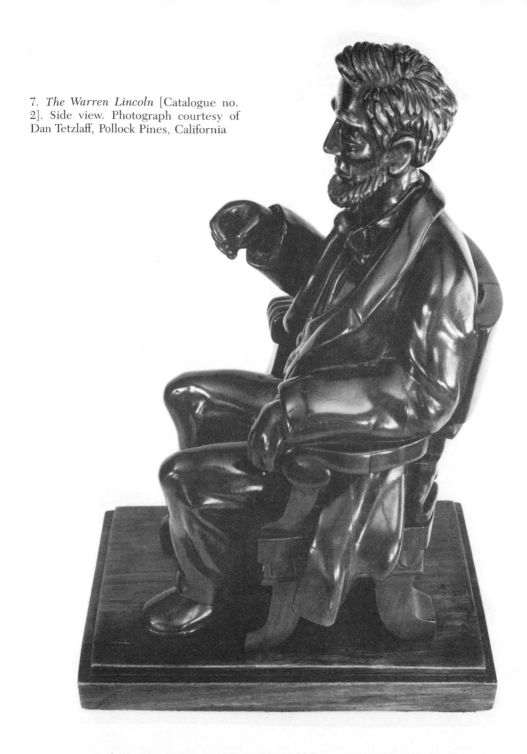

7. *The Warren Lincoln* [Catalogue no. 2]. Side view. Photograph courtesy of Dan Tetzlaff, Pollock Pines, California

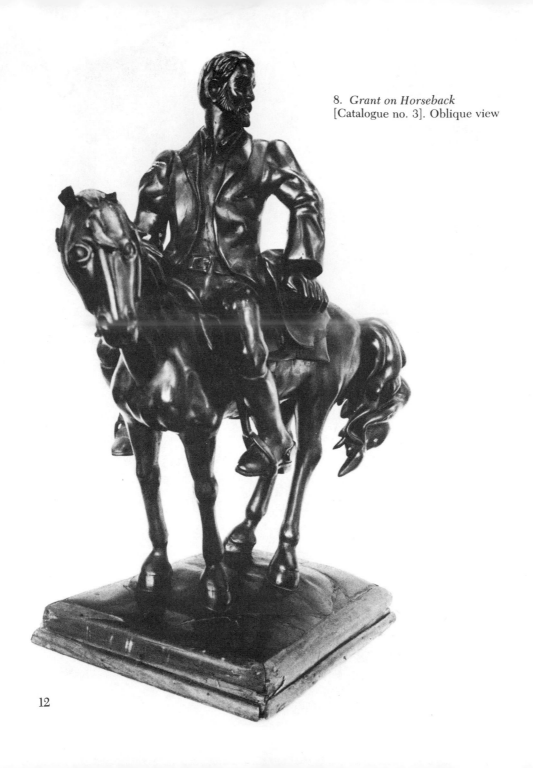

8. *Grant on Horseback*
[Catalogue no. 3]. Oblique view

12

9. *Crow* [Catalogue no. 4]

10. Moreau S. Maxwell,
March 12, 1979

12. Harold "Barber" Mitchell,
June 28, 1978

11. Brass casting of *Pete's Doctor*. This was done from the walnut carving, now lost. Irene Killian, West Frankfort, Illinois

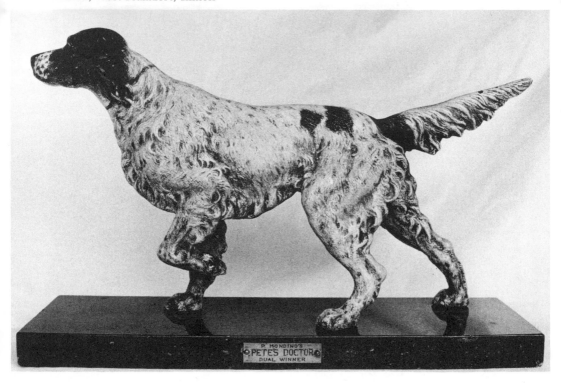

13. Left to right: Paul Bruce (Fred's cousin) and Fred Myers. Raymond and William Myers Collection, Litchfield Park, Arizona

No one seems to recall seeing Fred without those Oshkosh B'Gosh overalls except once when Fred attended a wedding where a tuxedo was required.[6] He wore a wool shirt in the winter and generally went without a shirt in the summer. He had wavy hair which seemed impossible to control except in the winter when he would wear a squared off cap with a short bill. Fred never went anywhere without his pipe, and many of his friends recall the Five Brothers' tobacco he used which they claim killed off more of his pals than anything else. Fred's brother referred to the tobacco as a great mosquito repellent. Raymond remembers: "We'd go hunting in the woods, and he'd go without a shirt. That's probably the outfit he wore going squirrel hunting in the bottoms, and the mosquitos ate me up. I've got a hunting coat pulled down around my ears you know, I'm sitting out there with all the mosquito dope I can get, and he sits there and they don't bother him a damn bit."[7]

15

Despite the fact that Fred could be quite a friendly fellow, he didn't make friends easily. If he liked you, he liked you a lot; but to get to know him was a very difficult task because he was quiet-spoken and didn't really have much to say. He seemed to be the type of person who would sit back, draw on his pipe, and let others do the talking. Jack Batts

14. Package of Five Brothers' Pipe Smoking Tobacco!

remembers going to see Fred during this time and Mrs. Myers telling him that Fred was at Freeman Spur. Batts went over to the tavern and saw Fred playing cards and having fun. As Batts started to leave, Fred left the game and they went back to the farm so that they could talk about sculpture. While Batts feels that he intruded on Fred, he understands that Fred was too gentle, kind, and considerate to let him leave the tavern alone.

There is also ample evidence of Fred's kindness toward other friends as well. Whenever they would drop by the house, Fred would always find time to sit down and talk with them. He enjoyed people and he enjoyed being with them. Although he was shy, especially around women, he was not particularly repulsed by them. Rose Pesula Hand recalled many pleasant conversations with Fred on the Myerses' front porch in West Frankfort. She would stand by the gate and he would sit on the porch. He never asked her to join him.

> He would open up about the friends who went hunting and fishing with him. That was a source of great pleasure for him. Politics? No. Didn't really interest him. Neighbors? Only casually. Of course, he was shy with women. I doubt if he ever had a date in the time I knew him. I don't think

he was afraid of women. He was perfectly at ease with me,
and I came on strong because I believed in him so
completely.[8]

Fred was uneducated in the formal sense, and his slow, easygoing
nature was balanced by a strong stubborn streak. Built like a mule, he
could also act like one at times. Maxwell in his interview repeatedly
refers to Fred's stubborn streak, at one point referring to him as that
"stubborn Dutchman." He had his own ways, and he was not willing, for
the most part, to change. Surely his artistic habits were difficult to alter.
He had not only an innate creative sense but also a deep understanding
of wood, the nature of wood, and as far as he was concerned that was all
he needed. When an artist with formal training in sculpture, such as Jack
Batts, attempted to explain to him things that would improve his work,
he tended to let it go in one ear and out the other. He would do this in a
good-natured way, but he really didn't accept either criticism or instruc-
tive help. Jack Batts states: "I think that he wouldn't have listened to the
finest sculptor. Rodin couldn't have told Fred anything."[9] But once again,
to show his kindness toward others, he would at least hear them out. This
courtesy he would extend to anyone who appreciated his art. Yet he
never considered himself an artist and was uncomfortable the few times
he was in the company of artists or intellectuals. Fred seems to have
succeeded in his carving because he ignored the pleas of trained
professionals.

Moreau Maxwell recalls that Fred didn't want to join those in the
Federal Art Project because: "[He thought] they were all lacy and weird.
They were doing horses that didn't look like horses and by God, he
wasn't going to go off with that bunch."[10] With a great deal of reluctance,
Fred accompanied Jack Batts to a Harrisburg art fair. Batts wanted to
show Fred what other artists were doing but he quickly realized that
Fred had no real kinship with those people. Without his carvings and
wearing simple, bib overalls, he appeared to be anything but an artist.
Batts felt the kindest thing he could do for his friend was to take him
home.

Two events occurred in 1936 that altered the Myerses' life-style. One was the closing of the Old West mine. The second was the move to the Bellini farm in a town known as Pershing or Ezra or 15, six miles southwest of West Frankfort on Route 15. The closing of the mine meant for Fred the termination of a fairly pleasant phase of his life. He took a quantum leap in putting those cartoonlike drawings behind him and tackling the monumental works that were to have significant expressive content.

The Myers family's early years in West Frankfort had seen four moves from one rental property to another. The farm at Pershing offered more

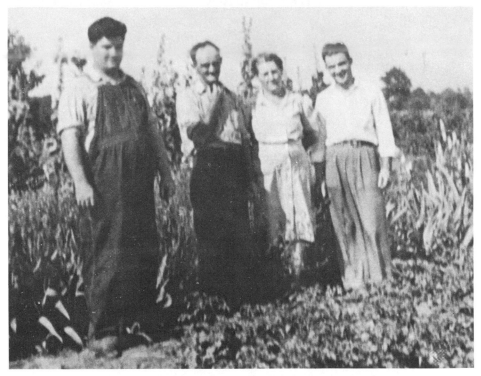

15. Left to right: Fred, James, Louana, and Raymond Myers at the Pershing Farm, ca. 1939–40. Raymond and William Myers collection, Litchfield Park, Arizona

16. Frank Tresso,
September 26, 1978

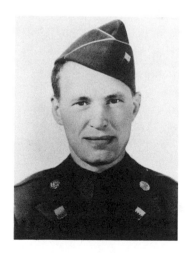

17. Dan Bellini, ca. 1942. From a service
portrait. Raymond and William Myers
collection, Litchfield Park, Arizona

space in which to live and to raise crops. Fred also gained from the move. He now had two places to carry on his wood carving: the basement and a small studio that he had built adjacent to the house. The large front yard was an ideal location for storing the walnut stumps supplied by Frank Tresso, a good friend, and those stumps that Fred and Geno grubbed together on their numerous hunting excursions.

Throughout this time, except for the war years, Dan Bellini lived with the Myerses. They paid Dan a minimal rent until they finally purchased the farm in 1946.[11] During the depression years many families were doing this sort of thing. They came together out of necessity and pooled their resources. From all indications, Dan appears to have gained a second family, good meals, and a strong sense of home. Close friends of both Fred and Dan recognized the fact that Dan was almost an adopted member of the Myers family.[12] The Myerses promptly settled into their new home by gardening, selling vegetables in town, setting out fence posts, and taking care of the apricot trees that Dan had planted earlier.

With the move to the farm, Fred's circle of friends grew. Despite the fact that he made fewer visits to West Frankfort, he maintained his friendships there. Many of his carvings during this period were displayed in Barker's drugstore, Walker's men's store, and Pete Mondino's poolroom. His friends from West Frankfort also paid sporadic visits to the farm. Many of the remember the overflow of aging walnut stumps in the Myerses' yard. Jack Batts recalls one stack out behind the house that measured about ten feet high, fifteen feet wide, and twenty feet long.

Fred spent most of his free time in Freeman Spur just West of Pershing. He would appear between 4:30 and 5:00 P.M. regularly in either the Amati or Tolluto taverns. He'd drink a few ice cold mugs of Falstaff beer which was on draft, munch a few bags of popcorn, and play a few card games of pitch. But he was always home by nightfall to be with his mother. Kenneth Lazzeri recalls a youthful incident at Tolluto's tavern.

> Fred said that he wanted a dish of beer and he was teasing me because I was behind the bar working when I wasn't supposed to because I was too young. And one day Fred

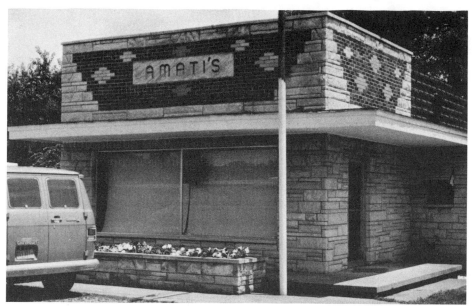

18. Amati's tavern, Freeman Spur, Illinois

19. Tolluto's tavern, Freeman Spur, Illinois.

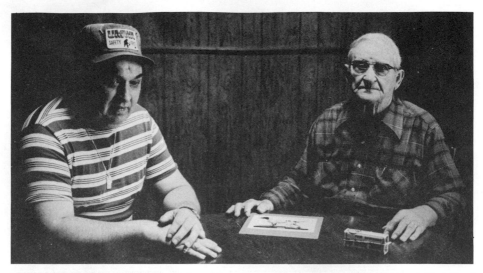

20. Left to right: Kenneth Lazzeri and Joe Tolluto, May 1, 1979. They are seated at Fred Myers's favorite table in Tolluto's tavern, Freeman Spur, Illinois

came in and asked for a beer, a dish of beer, and Fred always liked to have his mugs in the cooler, like A&W Root Beer. So I put a dish in the icebox to get it really chilled up, and so I poured him a dish of beer in a small saucer. And Fred kidded with the family about charging ten cents for a dish of beer. It was too extravagant or too much.[13]

The farm was also a favorite stop for the neighborhood kids. If Fred was working out-of-doors and he saw them, he'd call them over to watch. This was unusual because Fred didn't like to carve when anybody was around. If anybody came to visit, he'd stop, stand there, and light up his pipe. But Fred was particularly patient with children. He'd fix their toys and would give them tools and wood if, for no other reason, than to keep them out of his hair. "He'd give us advice on how to carve wood, but it was lost on us kids. We were only ten years old and had a short attention span."[14] Fred would also model miniature pipes and guns for the kids to play with, a chair for Frank Tresso's boy, and a chain made from a broom handle. Lazzeri can still remember playing king of the mountain atop the stack of wood stumps in Fred's front yard. William Myers, Fred's nephew,

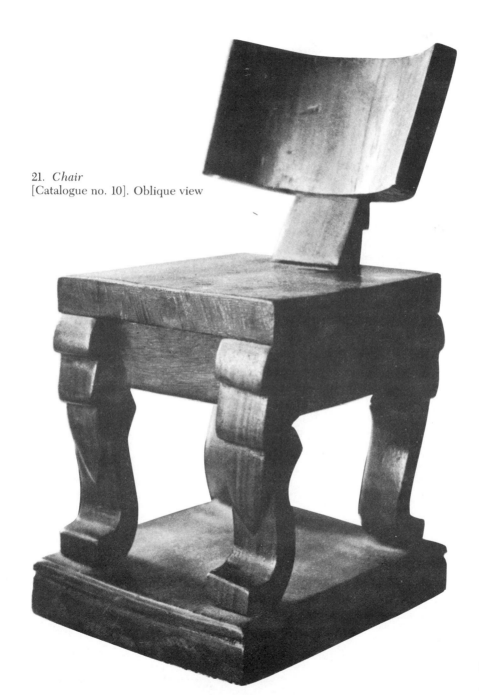

21. *Chair*
[Catalogue no. 10]. Oblique view

remembers that on Christmas Eve, 1949, when he was only three years old, he received from his uncle two hand-carved toys, a tricycle and a wagon, the latter of which was filled with Hershey bars. Finally, as Raymond remembers, "Fred used to bring eggs from a farmer that worked in the mines; bring them down to this lady. She lived a little way down from us. She had a little girl. She was always sticking her tongue out at Fred. And every time he'd bring eggs, he'd have a picture drawn on there with a tongue stuck out."[15]

The depression did strange things to many families, yet the Myers household held together fairly well during those trying years. In 1937, there was a brief upswing in the economy, and for a while it looked as if the worst was over. But all too quickly another recession developed and the hope for brighter days dissipated. The depression created a desperate, hopeless feeling in those who weren't able to find or keep jobs. There was a great need to drink, to forget. It is interesting that Franklin Delano Roosevelt, as well as the nation, sensed the need to repeal the prohibition amendment. Unable to keep a job, James Myers turned to drink and to taking out his frustrations on others. Being unable to hold a job did not mean he was unwilling to work. In many instances joblessness was forced upon him. He would work for four or five months and then be out of work. This was when the drinking began, and it was also during these periods that Fred was concerned for his mother's safety.

Fred continued to carve during this period and by 1938, when he was twenty-eight years old, he had completed his fourth major piece, a figure of *Jefferson*. A number of his pieces might have sold for good prices, but with the exception of a twenty-five dollar prize he won at an art show in West Frankfort, Fred didn't attempt to capitalize on his ability. Carving was still his hobby. In fact, Fred refused to enter any more of his work in exhibits after his experience at the Illinois State Fair in the summer of 1938. He sent *The Warren Lincoln*, which he felt displayed greater technical awareness than the earlier Lincoln carved in 1929. It was awarded a second-place ribbon in the Arts Division. Fred remembered: "I got the ribbon all right, but the statuette didn't come home. Months and months

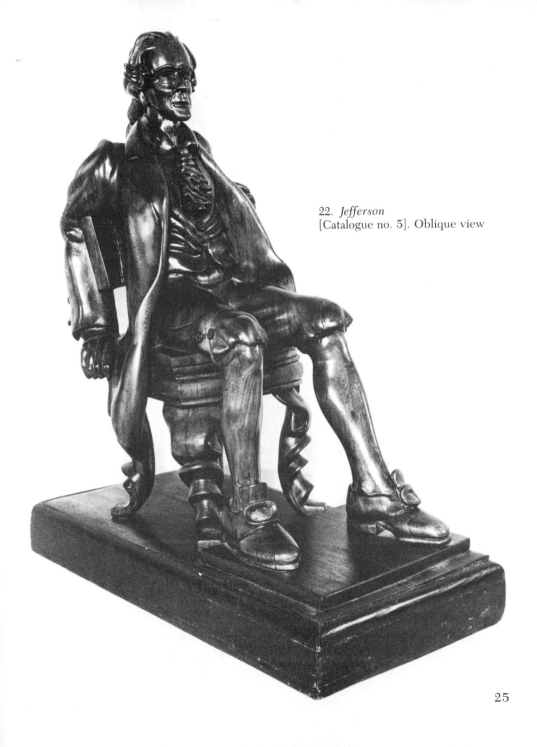

22. *Jefferson*
[Catalogue no. 5]. Oblique view

after the Fair was over, I finally managed to get Lincoln home. Where had he been? Why it seems that Governor Horner was an enthusiastic Lincolnian. My Lincoln had been sitting on his desk all that time."[16]

Appendectomy, 1938

During the summer of 1938 the Myers family underwent its most severe trauma. Fred had complained of having abdominal pains for several days, and an early diagnosis by Dr. Alberts seemed to indicate acute indigestion. Fred's father went over to Frank Tresso's to tell him that Fred would not be able to help in painting the Tresso's basement because he was sick. Fred's condition continued for several more days. Jack Batts visited him and saw that he was not well, and Frank Tresso and the family were worried about him. Frank was able to convince Fred to see Dr. Barnett, the Tresso family physician, who recommended immediate surgery. Frank's brother Louis tried to get A. O. George, the Denning Township supervisor who was in charge of welfare, to pay for Fred's operation. For whatever reason, Mr. George would not do it. By this time Jack Batts had gone to the farm again. Fred was sitting up in bed, was cheerful, and was eating some pie. In his euphoria, Fred declared that he was cured.

Fred's appendix had ruptured, which temporarily relieved the immediate tension and pain; but subsequent nausea from the spread of peritonitis spurred Frank on to find Louis, who was on his ice route. They called Dr. Barnett and said that they were bringing Fred to Union Hospital and they would pay for the operation. The hospital, like other hospitals during the depression, would not admit anyone who did not pay the bill in advance. Frank took his Model A Ford two-door convertible out to the farm. He and Louis got Fred into it, although Fred resisted, saying, "I don't want to beg from anybody." At the hospital Dr. Barnett made a horizontal incision across Fred's entire abdominal area in order to clean out the peritonitis. A few days later a second operation, which

23. Louis Tresso,
May 12, 1979

entailed making a vertical incision from his sternum to his groin, was
performed to clean out more infection.

Frank Tresso stayed with Fred constantly over the next few days be-
cause Fred nearly died. Fred remained in the hospital for several weeks,
even though that was not long enough. He was anxious to return to his
family, and he left the hospital long before he should. His friends and
family remember that this was a very traumatic experience for him. Geno
Casagrande says: "Boy that man suffered. They hurt him so much in the
hospital that he'd sooner die than go back to the hospital. And that's the

way it was." When Fred returned home, he vowed that because of the suffering he had experienced no doctor would ever touch him again.

Soon after his return from the hospital he ruptured his incisions by physically stopping an argument between his father and mother. He had acted in this role before and he would do so in the future. In addition, his continued carving put stress on his stomach lining. His abdominal wall never healed properly, and he was in almost constant pain from an incisional hernia on his right side which was almost nine inches in circumference. He had to push the bulge of his intestines back into his body cavity several times a day, especially if he were carving. Geno Casagrande and Ralph Murray, the WPA worker who took over as Fred's helper after Geno left, state that Fred was forced to wear an elastic bandage around his abdominal area to help keep his hernia in place.

Despite the seriousness of Fred's physical condition, there was no indication of error on the part of the doctors in diagnosing the appendicitis, nor did the family, as Raymond Myers states, place any blame on them. A congenital condition placed Fred's appendix more to the rear of his abdominal cavity than is normal. A knowledge of this family trait was to prevent similar mistakes in the cases of two of Raymond's children at a later time when the doctors initially diagnosed their conditions as upper respiratory infections.

An additional factor in causing the delay in taking Fred to the hospital was the fact that the Myerses' sporadic employment in the mines had caused their medical insurance to lapse. They did not have the money to pay the bill, and Fred's pride would not allow him to beg from his friends.

As a result of these operations Fred was never able to do strenuous underground work in the mines again. This frustrated him, since he had always been an active man who had contributed his share of income to the family. He was not supposed to do any heavy lifting, although he would still lift the walnut stumps. Sometimes he would have Geno Casagrande or Ralph Murray help him. His father did not want Fred lifting the stumps, fearing further injury to an already damaged stomach lining. At the time of the operation Fred was only twenty-eight years old, a

relatively young man by any standard. It was hard for him to face the next thirty to fifty years as a person who could never function with the Samson-like strength that he had once possessed. Fred had to rely on his father and brother to support the family, at least until he could find another job, although he never did try to get work in places such as gas stations or hardware stores. In an article in the June 14, 1948, *Southern Illinoisan* there was no mention of this traumatic time. Fred was quoted as merely saying, "I quit coal mining in 1938."

The WPA and the Southern Illinois Normal University Museum, 1939–42

During the winter of 1934 and the spring of 1935, the Roosevelt administration sought means to deal with the ever increasing number of unemployed. In 1935, the Works Progress Administration (WPA) was created by executive order. (The organization was redesignated Work Projects Administration in 1939.) The activities of the WPA reached almost every community in the nation, and its job descriptions covered almost every conceivable occupation.

The museum activities, because of their undramatic nature, failed to attract public attention as did other WPA activities, and therefore were not an object of adverse publicity. Individuals working for the museum at Southern Illinois Normal University were paid directly from WPA funds and were not a part of the larger Federal Museum Program. The rehabilitation of museums, valuable though it was, could be judged only by the quality of exhibits, the striking nature of displays, the appearance of the facility, and not by the workers responsible for the transformation. The museums hired preparators who possessed a myriad of talents from photography, taxidermy, and cartography to wood carving. Their products were essentially educational: models, dioramas, costumes, and crafts objects. It was as a museum preparator that Fred Myers became a part of the WPA in February, 1939.

During 1939, Fred Cagle was placed in charge of the museum at Southern Illinois Normal University. How Cagle heard of the West Frankfort wood-carver is still somewhat shrouded in mystery. It now seems likely that Cagle saw Fred's work at local art fairs. At some point Cagle, along with several assistants, went to the farm in Pershing to watch Fred work. To show his independence on this occasion, Fred demolished a piece he

24. Fred R. Cagle. Courtesy of Clarence Cagle, Marion, Illinois

was working on with his double-bitted ax. Cagle and the students beat a hasty retreat. The point was obviously made. Although the observation session proved to be rather frustrating, they saw Fred's potential and

how his carvings could become still another resource for museum displays. The carvings of prehistoric creatures that Cagle envisioned would work well with the stuffed animals and plaster casts already under construction.

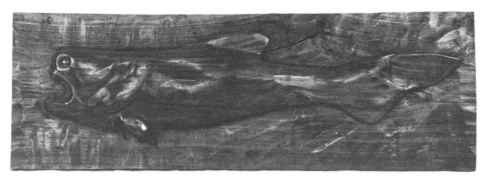

25. *Dinichthys* [Catalogue no. 12]. Side view

26. *Plesiosaurus*
[Catalogue no. 22].
Oblique view

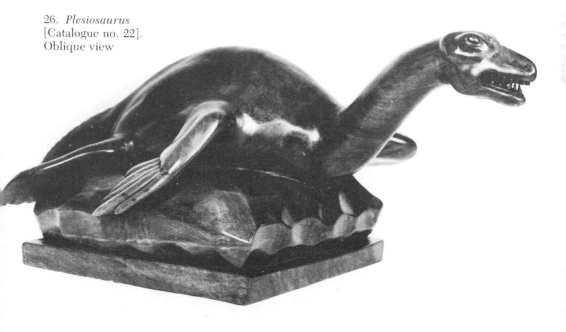

Fred experienced frustration and anxiety while working for Cagle, while carving such figures as the *Dinichthys* and the *Plesiosaurus*. Often he was given less than a month to complete a work, and Cagle seemed to be more concerned with the finished product than with the welfare of the artist. Fred was also concerned about the quality of his finished pieces because he felt they were being rushed to completion. This has been verified to a degree by the use of a white-oak plug in which a walnut *M* was embedded. This appeared on the carving if Fred had the time to complete it to his satisfaction. Geno Casagrande recalls, "He [Fred] put that [the *M*] on there because if they ever sold some of these [the carvings] they was going to give me and Fred a percentage." Somehow Fred and Geno were misled. The carvings were the property of the government and could not be sold.

Geno Casagrande bemoans the fact that whenever Moreau Maxwell, or whoever the representative from the museum might be, came by at the first of each month, he and Fred were obliged to turn over a piece. "They wanted them right away," Geno recalls, ". . . they had to have them right away, and Maxwell wanted them right away, he got to have them down there to display." This surely provoked anxiety in Fred who often could take up to eighteen months to finish a work. It also possibly explains his mixed emotions about those "intellectuals" at Southern Illinois Normal University.[17]

Despite these feelings, the WPA experience gave the Myers family a chance not only to survive but to get ahead and even to put money in the bank. However, Fred didn't think of it as his money; it was the family's money to save for what eventually became the purchase of the Bellini farm in 1946.

It was during this time, through his friendship with Moreau Maxwell, that Fred had another chance to work in the Chicago area. Maxwell remembers:

> And just before, this must have been, late in 1940, I suppose, or December 1941, it must have been some time in early 1941, I had gone to Chicago and had somehow made

contact with someone in the auto industry and I found out
that they were just desperate for pattern makers. And so I
kind of lined up a possible job for Fred, as a pattern maker,
at two hundred dollars a month, which was, I was making
one hundred dollars being supervisor, and two hundred
dollars for Southern Illinois was a lot of money, and he re-
fused to take it.[18]

Fred was later to comment on this offer with "it was too far from the
creek." In fact, Fred was nearly cut off the WPA rolls because of his
refusal to take the job. The WPA was a relief project. If one had a job
offered, one had the obligation to take it. So money was important, but
not quite as important as family.

Fred's relationship with the Southern Illinois Normal University Mu-
seum, despite all the difficulties, proved to be the prime of his creative
life. Not only did he carve thirty-five pieces for the museum, but he also
carved twenty-five pieces on his own time. This output represented fifty
percent of his total works. Without the pressure of producing one piece
per month, his output would have been far less.[19]

Capt. A. G. Foote was in charge of the Marion District Five office of
the WPA. In this capacity, he looked after all WPA jobs in southern
Illinois. He was aware of Fred's inability to do heavy, sustained work, so
he responded to Fred's request for an assistant. Fred had just met a
young Italian fellow by the name of Geno Casagrande, and he enjoyed his
company. Geno lived with the Wysop family of West Frankfort. It was
through the Wysops and Dan Bellini that Geno met Fred. Geno had
learned something of sculpting in Italy, and he seemed like the perfect
companion and assistant to Fred. Captain Foote placed Geno on the relief
rolls and temporarily got him a job with a local WPA road crew. Geno
worked as a laborer for only two weeks before he was informed that he
had been transferred to work with Fred. In this capacity, Geno was
working directly for the WPA and not the Southern Illinois Normal Uni-
versity Museum.

The museum at Southern Illinois Normal University was basically a
natural and social sciences museum. All the materials produced, such as

the dioramas and exhibits, were meant to be completed as rapidly as possible so the museum could be expanded. The museum had been in existence before Fred Cagle joined the staff, but it generally limped along. A year prior to Cagle's assuming the directorship of the museum in 1939, the Museum and Visual Education Committee, with Thomas F. Barton as its chairman, had been formed by Roscoe Pulliam, president of the university, to oversee administratively the development of the museum and the film library. The committee's responsibility did not extend to the day-to-day operations of the museum, which was headed by Cagle, but Joseph VanRiper, who was assigned by the committee to assist in the museum, and Cagle kept Barton and the committee informed about acquisitions and the hiring of people such as Myers. The availability of WPA employees and the arrival of three dynamic individuals—Cagle, VanRiper, and John Allen—resulted in a combination of talents that shaped the future of the museum for many years to come.

Fred Cagle was a man on the move. He was driven to do the best job possible in the shortest amount of time, and he had the support in this effort of Roscoe Pulliam.[20] Cagle also surrounded himself with success-oriented individuals such as Lendell Cockrum and Moreau Maxwell. These men have all gone on to establish fine teaching and publishing records.[21] The museum became a springboard for their careers.

While the museum was geared toward natural history and social sciences, there was a conflicting undercurrent that was to surface almost immediately. It was provided by Moreau Maxwell and John Allen who thought that the museum should be more than just a place for the repository of things to use in the classroom. They also felt, unlike Cagle, that Fred Myers's work did have artistic merit and that it should be considered something beyond mere "production."

Continued day-to-day operational conflicts, which did not involve the Museum and Visual Education Committee, soon developed between Maxwell and Cagle over Fred's work and other museum activities.[22] The museum, for instance, wanted Fred to turn out more than one piece per month, and Cagle could not understand why Fred couldn't work faster. Cagle's demands weren't guided by any aesthetic. He generally pushed

27. John W. Allen. Courtesy of Photo-
graphic Services, Southern Illinois Uni-
versity at Carbondale

Fred through other people rather than himself, since he seemed to sense
that he couldn't deal with Fred. Cagle must have been frustrated by
Fred's lackadaisical attitude, particularly since he could control all of his
other workers. Maxwell remembers how Cagle kept everyone busy, but
he had little control over Fred.

Moreau Maxwell on the other hand, was more easygoing, even though
he was busy. He states, "By gosh, I was a twenty-one year old kid, and I

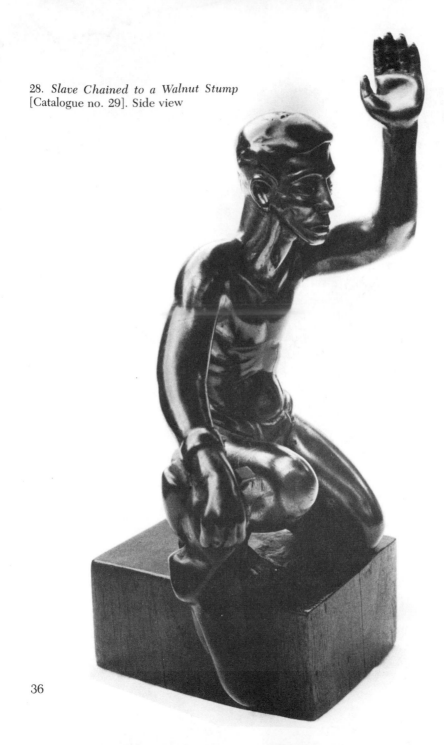

28. *Slave Chained to a Walnut Stump*
[Catalogue no. 29]. Side view

had six hundred lives in my hands because I had to administer it . . . and by God I did."[23] Maxwell could be at ease with people where Cagle could not. So Cagle would send out other people to try and urge Fred to work faster. Fred took all of this with his regular sense of humor. In fact, he did a carving for Cagle, the *Slave Chained to a Walnut Stump*. Fred probably saw himself as chained to the stump and in a sense at Cagle's command.

But Cagle pushed everybody, even himself. He was in a hurry to establish a museum. He judged the value of a successful museum by the number of objects it exhibited. And Cagle used Maxwell to get Fred to work faster. But Maxwell wouldn't always push Fred because Cagle couldn't totally control Maxwell who received his paycheck from Chicago and not the museum.

Maxwell's frequent visits out to the farm in Pershing grew into a real friendship with Fred. Maxwell recalls pleasantly: "I was single and I had a big car and used to like to roll around. Lots of times I would just go out and see him for fun. I loved to watch him work." When John Allen joined the museum program he became the contact man with Fred, but Maxwell continued to go out to the farm. "I used to go out every chance I'd get and take a little time off the Project and go out and watch him carving on this. And I was just fascinated by it. I would say, 'How in the hell can you do that?' And he said, 'Well anybody can do that.' And I'd say, 'Baloney!'"[24]

John Allen's association with the museum would be a long effective one. He inherited the museum when everyone else had gone off to war. And with Allen the museum changed direction. It was still a natural and social sciences museum, but Allen's interest in local southern Illinois history and folklore resulted in a new emphasis. He approached Fred with the idea of doing a series of southern Illinois character types which would spearhead this new emphasis. Barton gave the go-ahead for this project as he had done earlier with Cagle and VanRiper for the prehistoric series.

It appears that Fred was excited about this possibility. His frustration with the prehistoric images Cagle supplied from drawn illustrations by Charles Knight was apparent. For example, Fred did a carving of a

Stegosaurus from a Knight rendering, but because the drawing showed the animal in an action profile, it did not indicate the two rows of spines on the back of the animal's tail, with the result that Fred carved only a single row. When Maxwell saw the piece he knew immediately that Cagle would not accept it. He asked Fred if he could insert another row of spines, and Fred's reaction was typical. He reached down, picked the piece up and with one hand tossed it over his head and over the shed onto a pile of old wood destined to be burned. Maxwell came back a couple of weeks later and the *Stegosaurus* was still on the pile turning gray in the intense sunlight. Maxwell inquired if Fred intended to burn it, and Fred said that he did. So Maxwell asked if he could have it. Fred replied: "Sure. Take it. It's of no value." This episode reflects a number of things about Fred and his art. First was his cavalier attitude toward pieces that didn't measure up to his standard of perfection. Second was Cagle's need for accuracy. Finally, it reflects the difficulties Fred was having deciphering the drawings supplied by the museum. There exists one rare preparatory drawing, of a *Glyptodon*, that Fred did not burn. Until recently it was thought to be by Fred's own hand. The consensus now is that it was drawn by Alyce Pulley for the museum to give Fred an idea of what the creature looked like. So Fred must have been enthusiastic about returning to human figures. He had started off with people: the two Lincolns, the *Grant on Horseback* and the *Jefferson*, so people were very important to him.

Rose Pesula Hand was also angered over the treatment Fred was getting from the museum. She and Maxwell felt that Fred would have gained not only more fame and importance, but that his art would have grown had he been affiliated with the Federal Art Project rather than the Southern Illinois Normal University program. The director of the Chicago Art Project, George Thorp, was aware of Fred's presence in southern Illinois and was anxious to get him on the art project.[25]

Throughout our nation's history, the United States government had periodically commissioned works of art for the embellishment of its public monuments and facilities, but it had never sought to patronize the artist directly—not at least, until the establishment of the Federal Art

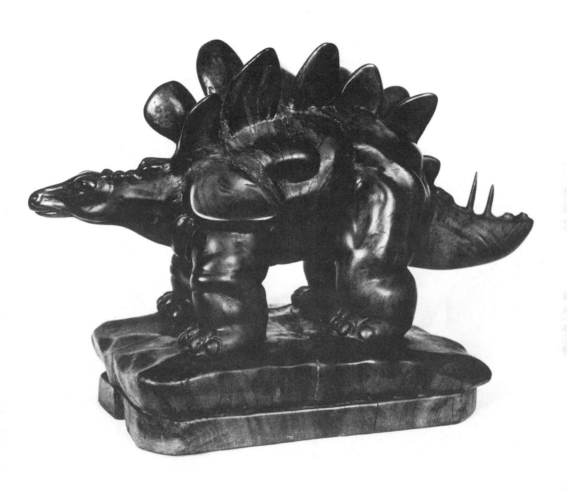

29. *Stegosaurus*
[Catalogue no. 26]. Side view

Project (FAP). It was with the establishment of the FAP that the federal government shifted its interest from art to the artist. By 1942, the government had hired and sustained over five thousand artists across the country. The FAP initiated many programs putting to work the diversely talented artists. There were typical easel and sculpture programs, art education activities making use of unemployed art educators, and art research groups that preserved native American folk arts through the creation of the Index of American Design Project.

Cagle recognized Fred's value to the museum, and wanted to keep him at the university. Hindsight is always best, but it now appears that Fred was indeed better off working for the museum than for the FAP. In 1939, Congress enacted an eighteen-month furlough requirement for all FAP workers which meant that after an artist had been employed for eighteen months he was automatically terminated. Later the artist could reapply for FAP status. Working for the museum, Fred was not obliged to follow

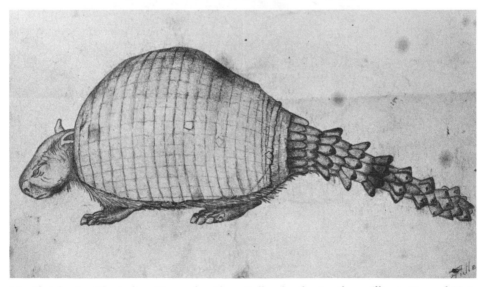

30. *Sketch of a Glyptodon*. Drawn by Alyce Pulley for the Southern Illinois Normal University Museum, ca. 1940–42. Raymond and William Myers collection, Litchfield Park, Arizona

such a plan; consequently, he was able to work for three uninterrupted years. So the FAP could have been important artistically, but Fred always looked upon his association with the museum as economic. Time and time again as newspaper articles state, Fred looked upon his wood carvings as a source of income. He simply did not look upon himself as an artist laboring for art's sake. Like most people of the time, he could not afford that luxury.

When the carvings were brought to the museum, they were quickly placed on display. While the stuffed animals and plaster casts were exhibited behind glass, Fred's pieces sat on ledges in front of the display cases throughout the large exhibit room in Parkinson laboratory. Unfortunately, no attempt to catalogue the pieces was initiated until the early

31. Southern Illinois Normal University Museum, located in Parkinson Laboratory, ca. 1942. From the John W. Allen Papers, courtesy of Morris Library, Southern Illinois University at Carbondale

1970s. Security seems to have been a problem from the very beginning. Numerous individuals interviewed mentioned the poor security at Parkinson. A letter sent to President Lay by Thomas F. Barton discusses the issue of security. Some of Fred's earlier pieces can no longer be located. The catalogue of the collection identifies twenty-three carvings, but it now appears that Fred did about thirty-five for the museum during his three-year tenure with it.[26]

Life and Working Habits, 1939–42

On almost any weekday, and even on Saturdays and Sundays, Fred would be preparing for the day's work by 6:00 A.M., long before Geno Casagrande arrived for breakfast around eight o'clock. Because he could not afford a car, Geno had to walk the familiar mile and one-half to the Myerses' home. After breakfast the two men descended to the basement of the home during the winter or went out to the shed in summer in order to commence working. Fred was attired in his standard outfit of shirt in winter or none in summer, bib overalls and a pipe. Fred would light up his Five Brothers' tobacco and go to work. Fred usually had a series of five to ten pieces sitting around the house, which pieces were in various stages of being roughed out from stumps taken from the large pile curing in the yard. While Fred was working on one of the roughed-out pieces, Geno was doing the final sanding, shaving, and defining on another piece. If Geno made a mistake on a muscle or sanded too deeply, Fred would give him hell. Often Fred helped Geno. Geno recalls: "He'd tell me how. 'Now see that? That should be like this.' And he'd do it. Sure enough, it would look better" or "He would get his knife out. First thing you know you could see the muscle come out. He would say, 'Now remember when you sand this, watch that muscle.'"

Geno had several other duties besides sanding. He was charged with repairing any split pieces that came back from the museum or ones that had split before they were sent out. He used horse-hoof glue to fit the

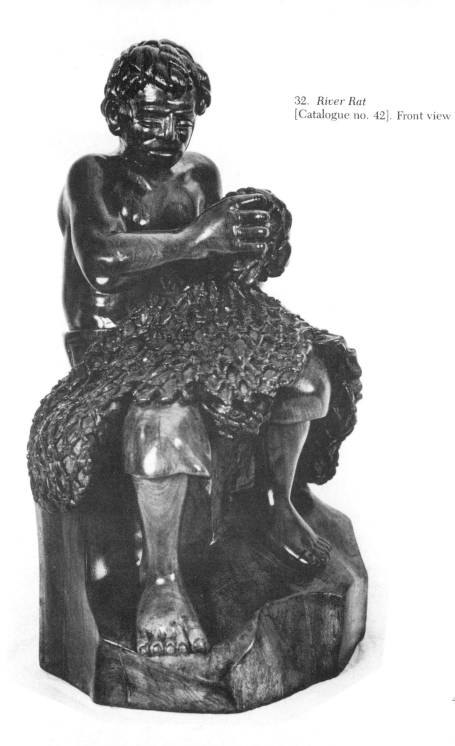

32. *River Rat*
[Catalogue no. 42]. Front view

pieces together or to hold the plugs that Fred had carved to fit into the cracks. Each night they doused the pieces in hot linseed oil to prevent cracking. After a piece was completed, Geno rubbed it down with Johnson's Wax. Geno developed another skill when they needed to add hair detail on the *River Rat*. Geno got a wire brush, of the type used for currying horses, and scratched in the final details of the hair.

Often Fred stopped to rest. He would lean against the wall, push in on his right side, and puff even more on his pipe. During these times he concentrated on the piece in front of him. Shortly he would begin again. If Geno noticed that Fred was still hurting, a ritual to break Fred's compulsion to carve would take place. Geno teased Fred, asked what a piece of wood was being shaped into, or even acted as though he did not understand what Fred was carving. Fred often teased in return. "Are you looking at it?" Outsiders and even some of Fred's friends believed that Geno was only a jokester who kept Fred laughing. If Geno saw that Fred was not resting and the other gambits had not helped, he would go upstairs under the pretext of going to the bathroom in order to force a break in the work. Although Mrs. Myers usually came down to see how the carving was going every two hours, Geno would have her go down and talk to Fred. She usually brought tea, a sandwich, or some pie to Fred. Fred let Geno know that he knew why she kept coming down.

The essential ingredient in Fred's carving was his intensity. Geno Casagrande, Jack Batts, Kenneth Lazzeri, and Victor Randolph all commented on it. Victor Randolph, who was a professor of elementary education at Southern Illinois Normal University, remembers Fred saying: "I just get so nervous [about carving] I want to bite my fingers. Just like I told ya, this thing [the hernia] keeps gnawing away at me when I'm carving, and it [the carving] makes me worse." At its worst, Fred's health suffered. Geno remembers: "One time he was hurt and he went to the hospital. He went three or four times [including the 1938 operations]. I was there. It was because we couldn't keep him off the chisel. And when he came home you couldn't keep him off." Fred would say: "Oh. I'll just watch it. . . . Aw. It's ok. I got that strap on there." But Jack Batts relates a story about Fred that explains how his compulsion to carve worked to his advantage.

Fred had a big double-bit ax, out there that was, would take a good man to swing it. And he said, "Come out. I want to show you my wood. And I need a little help." So I went out there. Fred had the burl from a piece of black walnut which was cut down near the stump, you know. And he said, "I want you to help me with this." So he takes a piece of chalk and he hauls this big thing out of the pile, gets it out clear, and takes this chalk and he makes a mark here and makes a mark there. Now this was not foreign to me because I know how you block out a piece of sculpture, but I didn't know what the son of a gun was going to do. He didn't bother to tell me what we were building.

So he says, "We'll take this crosscut saw." So I get on one end of the crosscut saw and he gets on the other, and we

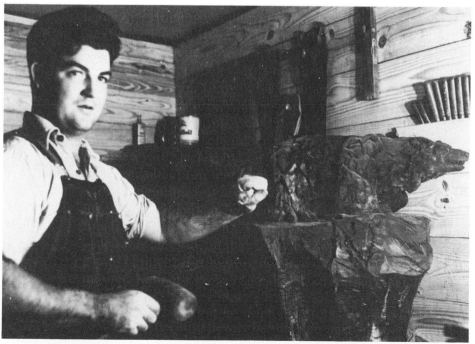

33. Fred Myers in his Pershing farm work shed. Photograph courtesy of Southern Illinois University at Carbondale University Museum and Art Galleries

start sawing at this big stump. We'd saw and he'd look and we'd saw, and he finally says, "Well that is about as far as we better go." So we go over and we cut in on another chalk line; and we'd keep this up until we've got quite a few cuts of this saw done. Of course I had understood thoroughly that he was blocking something in, but I didn't know what. If I had been building it, I would have known what. But he didn't talk. And if he had told me, it wouldn't have been clear to me.

Then he takes this big double-bit ax that he has and he saw that it was sharp and in good shape. So he squares off with that thing. And I moved back about twenty feet, realizing that anything closer was dangerous. And I never saw a man who could take an ax and knock such big chunks out at one time. I decided that twenty feet might not be a safe distance because he'd knock chips twenty feet away. And he finally, with this ax, began to block that thing out; and I stood there fascinated, watching him. Before he was through with it, with that ax, I could begin to see this thing taking shape. He was unbelievable. How fast he could work![27]

Fred had a tremendous pair of hands. Geno remembers that those hands used chisels more like a stonecutter than a wood-carver. Batts remembers his amazement that those huge hands could carve such delicate pieces as the small prehistoric horses. "I think Fred's brains were in his hands. His hands seemed to kind of be a separate part of his body. They just got the job done."

Fred's earlier primitive working tools and his limited supplies were supplanted by Southern Illinois Normal University materials: linseed oil, sandpaper, and a full set of chisels. Maxwell and Cagle, with some difficulty, got Fred a set of German carving tools, but they were too small and delicate for him. Earlier Fred had a blacksmith in the mines, Mr. Donaldson, fashion him a large brass mallet with which to work. Jack Batts also gave him a small chisel, which Fred promptly beat to pieces. Batts remembers: "I carved a lot of pieces of wood carving and in various kinds of wood with this chisel. And I'd never even hurt it. I just tapped on it,

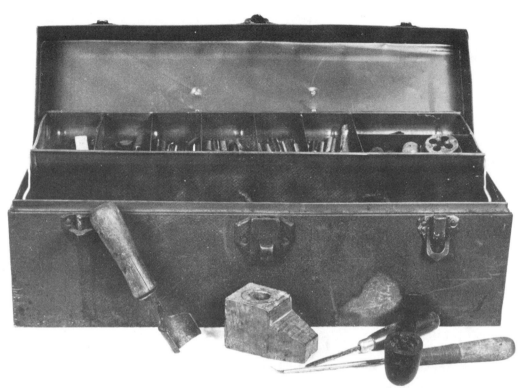

34. Fred Myers's toolbox, pipe, and chisels. Raymond and William Myers collection, Litchfield Park, Arizona

you know, by comparison. But Fred rared back with that big three to three and one-half pound mallet that he had and the sparks'd fly. And he got work done and he did it in a hurry."[28]

Fred also had his shortened ax, a hatchet, and his hawkbill knife for finishing work. While he often carved white oak and wild cherry objects in the local taverns and always had the hawkbill knife with him (the blade of which he often popped open for fun as if it were a switchblade), it was a mistaken notion that this was the only tool that he had. Dr. Emmett Dunn gave Fred a set of used dentist drills to use for detail work such as that on the *River Rat*. Fred converted an electric motor to try to make

them work, but this was on the whole unsuccessful. Fred and Geno also got the engine from Louis Tresso's 1935 Chevrolet truck in order to rig up a kind of lathe for finishing work and for sharpening tools.

Fred's wood supply came from Frank Tresso who had a trucking contract with the WPA during the mid- to late 1930s. Many of the southern Illinois roads were being widened and improved and the Crab Orchard spillway area was being cleared. Frank's job was to haul in the "gob" from the strip mines for the roads. On the return trips he kept the road crews from burning the thousand- to twelve-hundred-pound black walnut and wild cherry tree stumps so that he could collect and deliver them to Fred. Frank's efforts injured his back, and the results of that injury are still evident.

If the carving was going along in good fashion Fred and Geno carved and sanded long after the four o'clock quitting time, often carving late into the night. They owed the WPA thirty hours per week in return for their paychecks. But they often exceeded the required hours. Moreau Maxwell says that Fred was the most conscientious and honest man that he had ever met. He did not consider the time he spent looking for stumps or grubbing them up as part of the WPA work. The thirty hours required was literally the time he and Geno carved.

Fred's days were divided among his WPA carving, working on the farm, and pursuing his favorite recreation. He hunted squirrels and geese and did some fishing. He almost always took a saw with him on these excursions. He would tell Geno or Frank, "Let's take that stump or tree limb back," and they would help him do it. Frank Tresso remembers taking Fred out to see a walnut stump that was four feet in diameter. Fred admired it but left it where it was, since there was no way they could move it.

In the evenings Fred would go down the road to Freeman Spur, arriving around 4:30 each day at either Tolluto's or Amati's tavern. Besides drinking his favorite beers, he also listened to music, carved pipes or small quails or other objects as gifts for friends while he drank, and listened to people talk. While he was not afraid of women, as Rose Pesula Hand states, he did not mix with them. He did not sit at a table in mixed

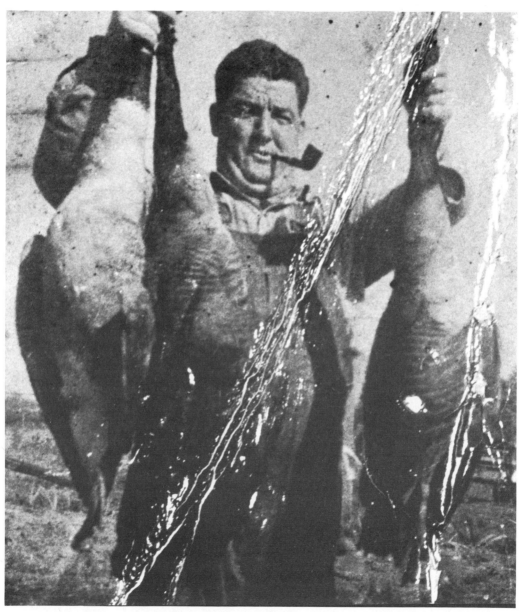

35. Fred Myers with three Canada geese, ca. 1942–45. Raymond and William Myers collection, Litchfield Park, Arizona

company. But he did enjoy good humor with both sexes. One time, Geno
had carved a nude caveman. Fred added an oak leaf to cover the cave-
man's front and he added a tail. When he brought it to the tavern, some
woman at the bar pulled the tail and the oak leaf fell off and revealed the
naked carving, much to everyone's amusement. Often Fred sketched
people, doing portraits for people he liked. If he disliked a person, as in
one case, he would sketch a scene with some people at the bar and one
horse's behind. The person he did not like received the sketch and the
message. Often Fred joined the men who sat on the huge fifty-foot-long
log outside Tolluto's to drink and talk. At dusk, Fred's socializing for the
day was over and he would go home.

Fred maintained a fine sense of humor beyond the evenings at the
taverns. When he was working on the *River Rat*, Maxwell came out to
see him. In fact, he came out to watch Fred and Geno work on the
intricate fishnet upon which the depicted figure was working. Fred said
to Maxwell: "Here is a block of walnut. Why don't you make one."
Maxwell declined. Fred said: "It is easy. All you have got to do is just
whack away at it." Maxwell tried and did finish a small, ill-proportioned
figure. Instead of a net, the figure held a concertina. Fred also tried to
help Geno carve. Like Maxwell, Geno always ran out of wood before the
carving was completed. For example, Geno carved a reclining nude on a
couch, but it did not have any feet.

Fred had many visitors. Besides Maxwell, Cagle, and Allen, there
were people who came to the farm because of an article in the *St. Louis
Post-Dispatch* of April 20, 1941. WPA people from Springfield and Chi-
cago as well as others from Southern Illinois Normal University made
pilgrimages. A woodwind salesman brought Fred some wood and
watched him carve.

Fred enjoyed the attention he received. When Batts or Maxwell ar-
rived, there was always a finished piece sitting on the dining room table.
He enjoyed his reputation among friends and family, but he valued the
professional approbation from artists like Jack Batts and Rose Pesula
Hand as well as university people like Allen and Maxwell. Yet Fred's life
was contained within a relatively small area. Other than his frequent

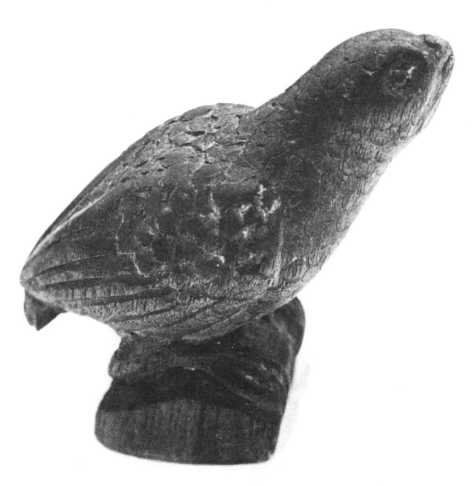

36. *Quail*
[Catalogue no. 11]. Side view

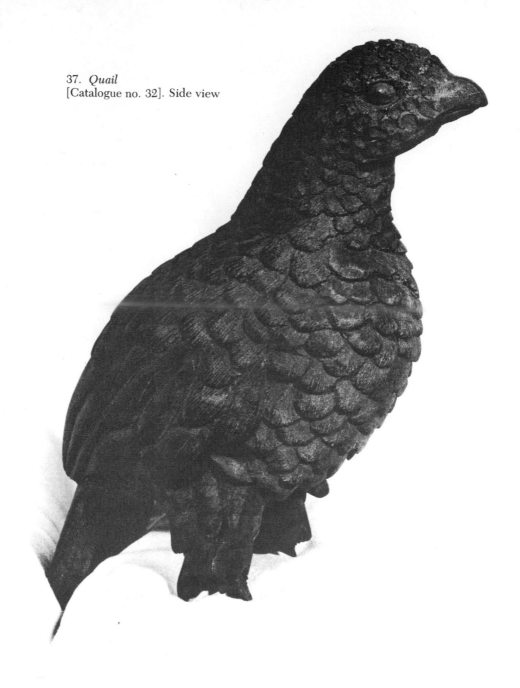

37. *Quail*
[Catalogue no. 32]. Side view

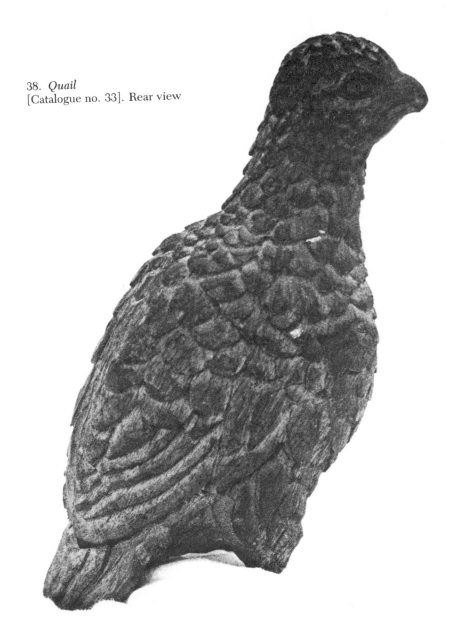

38. *Quail*
[Catalogue no. 33]. Rear view

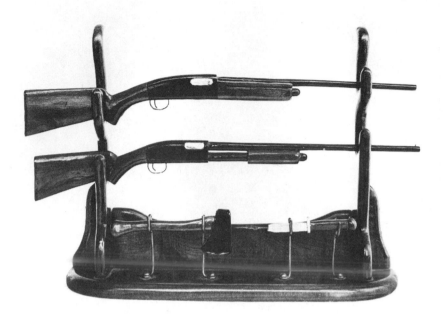

39. *Gun Rack*
[Catalogue no. 34]. Front view

40. *Fishing Tackle Box*
[Catalogue no. 6]. Top view

41. *Fishing Tackle Box*
[Catalogue no. 6]. Interior view

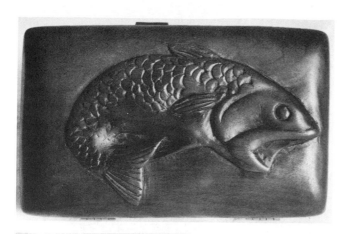

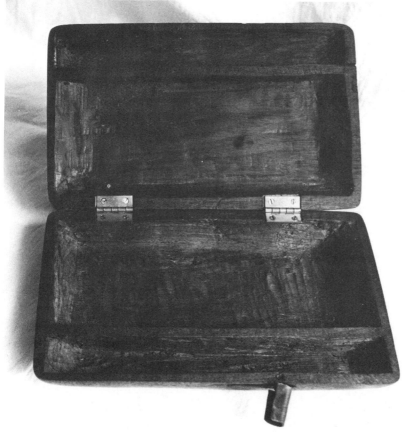

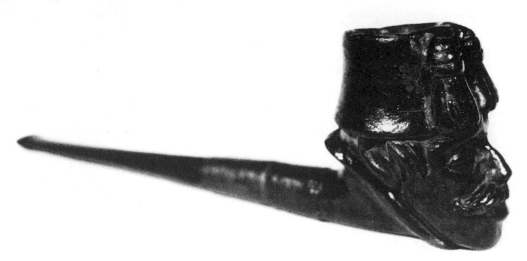

42. *Turk's Head pipe*
[Catalogue no. 48]. Side view

43. *Sketch of Turk's Head pipe*
[Catalogue no. 47]. Side view

hunting trips, a journey to take *The Warren Lincoln* to Springfield to the State Fair, an outing with Jack Batts to a Harrisburg art show, and occasional visits to Southern Illinois Normal University, most of his life was spent in a rectangular area bordered by West Frankfort, Pershing/Ezra/15, Waltonville, and Mount Vernon.

January, 1942, to December, 1947

On December 7, 1941, Raymond Myers and Dan Bellini came out of the Strand Theatre in West Frankfort to the news of the bombing of Pearl Harbor. Shortly after, in early 1942, they enlisted in the army. Mrs. Myers was never at ease about Raymond's enlistment and service overseas. When she received an overseas photograph of Ray, she cried when she saw how he had aged. In mid-1942 Fred carved the *Happy Soldier* plaque, now missing, from a service photograph that Raymond brought

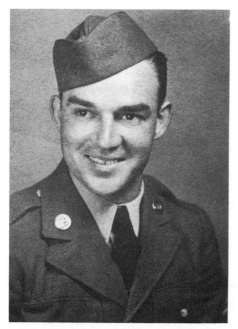

44. Raymond Myers, ca. 1942. Service photograph in the Raymond and William Myers collection, Litchfield Park, Arizona

home on furlough. Most of Fred's friends left to serve in the armed forces: Moreau Maxwell left in mid-1941 to become a marine pilot, Harold Mitchell and Howard Deason joined the army in 1942, and John Deason followed later in 1944. Fred tried to enlist on two occasions, but he was rejected both times because of his hernia.

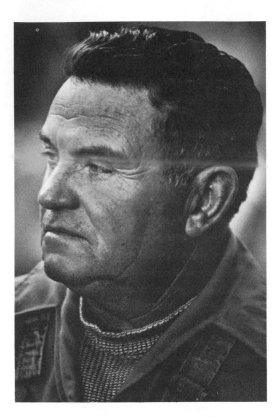

45. Howard Deason,
October 7, 1978

On January 2, 1942, Geno Casagrande left the WPA to work in Orient No. 2 coal mine. Although he hated to see Geno leave, Fred told him that he could make more money mining than the $48.50 per month he earned carving wood. Geno's family was growing and he needed a larger income. Shortly after he went to work in the mine he was drafted. He

returned the next month from Great Lakes Naval Training Station, having been discharged as a hardship case. He opened a nightclub in Zeigler, Illinois, on May 29, 1943, keeping it open until January, 1948. He bought a farm about a mile south of the Myerses. Fred often visited Geno's nightclub, but he told Geno, "I'm going to quit coming because I can't buy a drink here." Geno answered: "I says no! I say we went through the one [the depression]." After leaving the WPA, Geno did some finishing work on pieces for Fred until about April, 1942.

By 1942 John Allen had taken over the Museum, since he was too old to serve in the armed forces and was the only one left of the earlier group to run it. He had contributed heavily to the change in emphasis of the museum from natural history to arts, crafts, and folklore. It was natural that he should assume leadership of the museum. He expanded the educational program of the museum. Exhibits, dioramas, and many of Fred's carvings were sent on tour to local schools. Julius Swayne, a stu-

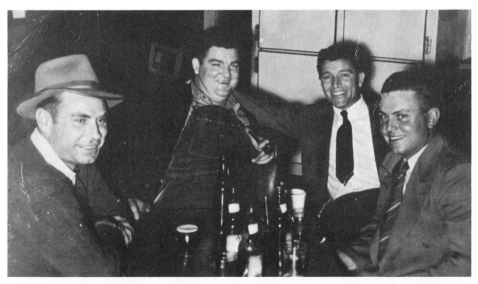

46. Left to right: Claude Franklin (a close friend), Fred Myers, Geno Casagrande, and Howard Deason in Geno Casagrande's Zeigler nightclub. Raymond and William Myers collection, Litchfield Park, Arizona

dent worker for the museum, kept the exhibits circulating until he was drafted in 1943; then Allen assumed the job.

By April, 1942, the Southern Illinois Normal University museum program was terminated. Fred was transferred to an arts and crafts extension project on the north side of Carbondale. The project was headed by Louise Pain, who worked in plaster casting and who was a faculty assistant in the art department at Southern Illinois Normal University from 1941 to 1944. Since Geno had left the WPA in early 1942, Fred needed another assistant. Ralph Murray of Freeman Spur, a twenty-one-year-old man who had been doing plaster casting on his own, was taught further intricacies of casting by Louise Pain. Fred asked if Ralph could be assigned to help him. Ralph Murray worked for Fred in the same capacity that Geno did, and he helped Fred complete six additional pieces over the next few months. It is believed that they worked on a *Mammoth*, a *Standing Indian*, a *Farm Horse*, a *Man*, and two others.

By December, 1942, Fred was dropped from the WPA rolls. Much of the Federal Art Project had already been altered so that those artists who had not joined the armed services were working for the Graphics Section of the War Services Program, which section created posters, painted camouflage, and designed recruitment booths. For all intents and purposes the projects which had meant so much to so many people had come to an end.

The end of the WPA left a void in Fred's life. He could not go back to heavy underground coal mining. Fred entered a fallow period of about a year because, after his tremendous output, he was somewhat burned out. John Allen, as had Cagle earlier, had Fred visit Carbondale on several occasions to see his creations at the museum. But he did not carve any more pieces for the museum or for the art gallery. Fred worked on the farm as he had in the past. He still hunted, but he did not bring back stumps. His mother was ill for an extended time, so he remained at home even more than usual. His father began making trips to Springfield to visit Ervin Warren and to be examined for a possible operation, since he had a black lung condition. Fred's own health deteriorated. He did not try to gain other employment.

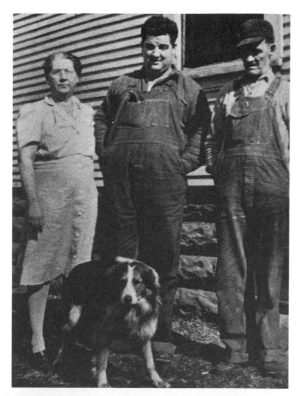

47. Left to right: Louana, Fred, and James Myers at the Pershing Farm, 1942. Raymond and William Myers collection, Litchfield Park, Arizona

48. Left to right: Fred and James Myers at the Pershing Farm, 1942. Raymond and William Myers collection, Litchfield Park, Arizona

While his friends were away at war, Fred continued to make his trips to the taverns in Freeman Spur and to Geno's nightclub in Zeigler. His weight had increased to about 260 pounds. Although he could not lift heavy objects, he still enjoyed great strength in his arms. He would playfully put strangle holds on Kenneth Lazzeri and others. They would try, unsuccessfully, to get free. Fred also enjoyed listening to the jukebox.

49. *Beavertail Fore-end*
[Catalogue no. 9]. Side view

50. *Shotgun Stock*
[Catalogue no. 49]. Side view

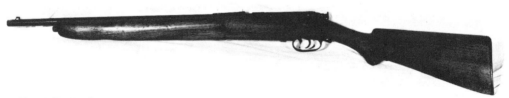

51. *Rifle Stock*
[Catalogue no. 50]. Side view

On one occasion, after he had played one song, "Troubled in Mind," many times, a man at the bar wanted to have some other selections played. He was informed that Fred, the big man, wanted to hear that

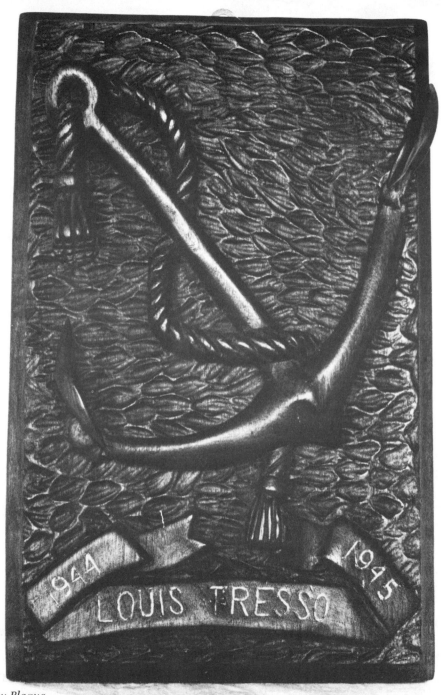

52. *U.S. Navy Plaque*
[Catalogue no. 44]. Front view

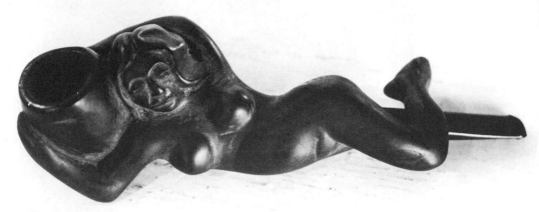

53. *Pipe*
[Catalogue no. 45]. Side view

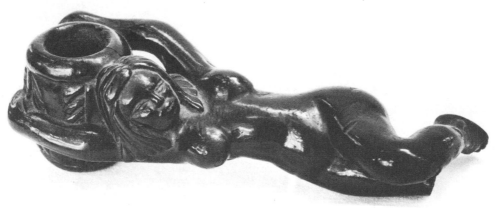

54. *Pipe*
[Catalogue no. 46]. Side view

song. It continued to be played.[29] Despite his humor and his gentleness, Fred could be angered. Once while playing cards at Tolluto's he heard a customer make a caustic remark about his mother being a gossip. Fred stood up, whipped out his hawkbill knife, and charged. It took five of his friends to calm him down, while the man beat a hasty retreat.

In 1944 Fred began carving again. He did a few cabinets for friends,

did handyman work, finished the back porch of the family farmhouse, and carved more pipes. His love of hunting took the form of carving gunstocks for people such as Louis Ruzich, Gus Peebles, and others. He wanted to do fancier, more ornate gunstocks, but Gus Peebles remembers telling Fred that if he made them too fancy his friends wouldn't shoot them. Gus told Fred that he would hang his on the wall.

By the war's end in 1945 Fred's father was working in the Freeman mine, having been off steady employment for nearly two years. Raymond returned in October, 1945, with his British war bride, Lillian, to stay with the Myers. All of Fred's friends had returned by 1946, and he quickly got reacquainted with them. Howard Deason brought back a German double-barreled shotgun and two sabers for Fred, which pleased him very much. During this time Fred carved two plaques from some of Louis Tresso's lumber—the *Illinois State Police Pistol Trophy* (which was sent to Springfield to Ervin Warren) and the *United States Navy Plaque* for Louis Tresso. He also carved a *Pipe* for Harold Mitchell and three for his brother Raymond.

In May of 1946, after Dan Bellini's return from the war, the Myerses bought the twenty-acre farm from Dan and his father, Arturo Bellini. Raymond and his family stayed until late 1946 when they left for Detroit, Michigan, where he went to work for General Motors. In late 1947 Raymond and his family returned to southern Illinois, and he went to work for Draybow Construction. In that same year two more newspaper articles appeared on Fred's work: one in the *Southern Illinoisan* and one in the *Daily Egyptian*, despite the fact that Fred had not carved a major piece in five years.

The Last Years, 1948–50

In June of 1947 the sinking of the mine shaft was begun for the Waltonville mine. Geno Casagrande, who had gone back to work in the mines in February, 1948, discussed with Kenneth Rodenbush, superintendent of

the mine, the possibility of hiring Fred. Rodenbush's friendship with Fred dated back to elementary school. Kenneth also knew of Fred's surgery and his inability to do heavy labor. Geno inquired about getting Fred a surface job, which was highly sought after. When a lamp job became available, Fred was hired.

Fred began the long daily trek to Waltonville from the family farm in Pershing. He worked the midnight to eight in the morning shift and would start out in his 1937 Chevrolet, which was lacking half of the windshield. Howard Deason relates that Fred didn't like the long drive in the dead of winter, and the fact that he had to leave his mother during the evening must have "troubled his mind."

In May of 1948 the Myerses sold their farm back to Dan Bellini and bought a house in Waltonville not far from the mine. This move, despite the financial burden, was important. The long, physically painful ride from Pershing was over. The roads at that time were in very bad shape,

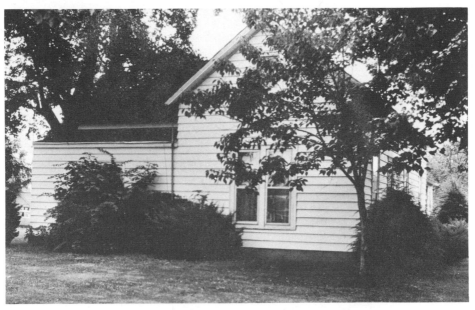

55. Myerses' Waltonville, Illinois, home, June 22, 1978

and the constant bumping must have been unbearable at times. The move to Waltonville also cut the traveling time so Fred could spend more time at home.

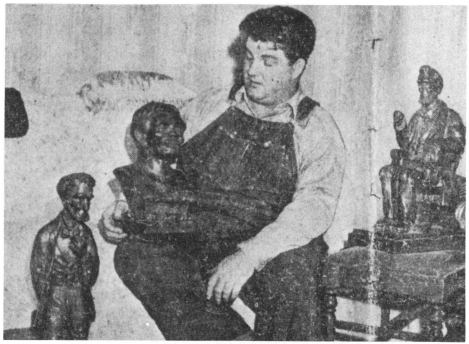

56. Fred Myers with his carvings in the Waltonville, Illinois, home. This photograph appeared in the *Southern Illinoisan*, June 14, 1948, and is reproduced by permission.

Fred's job in the lamp shack was simple and uncomplicated. He supplied the men with tools and maintained the charge on the hat lamps. Between the rush periods when the men were either descending or coming out of the mine, Fred had time to whittle and lie down for short rest periods. Throughout the period since he left the WPA, Fred's operation, which at this point had developed into a large intestinal hernia, was troubling him. Fred was in almost constant pain and the rest periods at the mine were essential. In July of 1948 the *Southern Illinoisan* did an article on Fred. The accompanying photograph showed him sitting on a

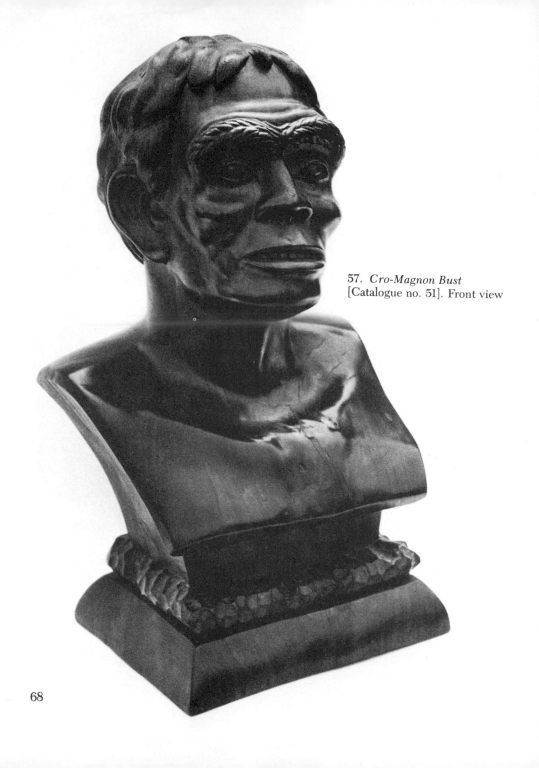

57. *Cro-Magnon Bust*
[Catalogue no. 51]. Front view

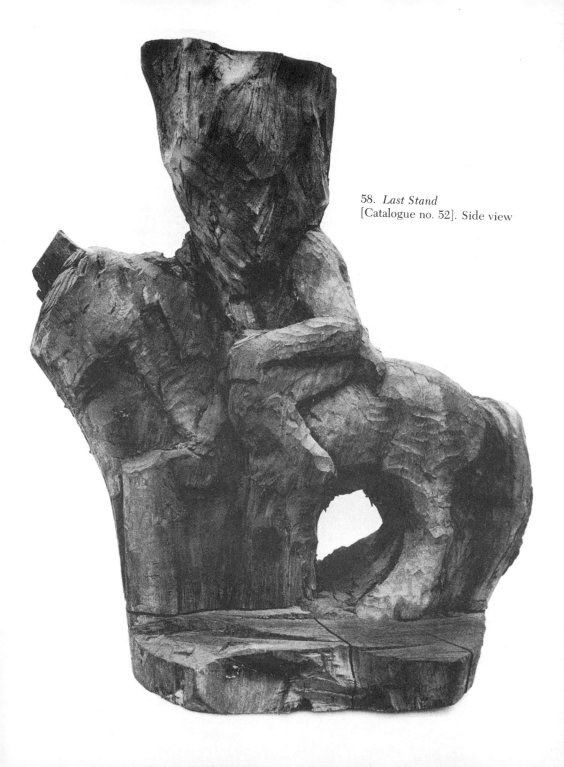

58. *Last Stand*
[Catalogue no. 52]. Side view

couch in the Waltonville home looking extremely tired and much older than his thirty-seven years. In the article, Fred stated that he was no longer carving because he was now receiving a monthly check from the mine and there was no need to carve any longer. This statement is refuted by coal-mining friends who state that he was working on pipes and at least two new monumental pieces identified as a *Cro-Magnon Bust* and the *Last Stand*.

Early in 1948 Victor Randolph, a professor at Southern Illinois University, wrote to Fred inquiring if he would be interested in doing a series of four prehistoric heads.[30] Professor Randolph had known Fred for some time and probably discussed the commission before sending a formal letter. The answer was enthusiastically positive and Randolph began a friendship with Fred that was to last until Fred's untimely death two years later. Randolph supplied Fred with photographs of the series of prehistoric busts sculptured by Malvina Hoffman which are on display at the Field Museum of Natural History in Chicago. He completed only one. Sometime earlier, possibly while Fred still lived in Pershing, he began his last testament, the *Last Stand*. There has been some conjecture that Fred knew he was desperately ill and that he probably had a premonition that he was not going to live much longer when he initiated this final major carving. The *Last Stand* became his own last stand. There is no documentation to support this theory, yet the idea is a compelling one. These two pieces represent the only major ones he worked on between the end of the WPA period and his death.

One would think that Fred had reached contentment. Wood carving now took its proper place once again as he returned to his first love— working in the mines with the men. His wood carving decreased but was not totally abandoned. Inwardly he was suffering badly. Despite Fred's enthusiasm for the prehistoric group project, Randolph, as quoted earlier, remembers Fred saying, "Just like I told ya, this thing [the hernia] keeps gnawing away at me when I'm carving, and it [the carving] makes me worse." Few people were aware of the earlier surgeries, and Fred didn't show or talk about his pain. For instance, few people knew that Fred had been wearing an elastic belt around his waist since the original surgery in 1938 to help keep the hernia in place.

Victor Randolph can no longer remember exactly why he took Fred to see Dr. Benjamin Fox in Carbondale. He does state that he was aware of Fred's pain and that Dr. Fox may have been familiar with Fred's case.[31] Dr. Fox recommended corrective surgery, but stated emphatically that Fred must lose some weight before the surgery could take place. Mr. Randolph remembers that Dr. Fox also volunteered to do the surgery free of charge. From his first operation in 1938, Fred had ballooned from 220 pounds to about 260. His diet consisted of a daily consumption of pies, sandwiches, and whatever else his mother fed him, plus his snacks at the local taverns. As Howard Deason observes: "Fred had a great love for Hershey bars and could devour a half dozen at a single sitting. I'm sure Fred ate himself to death."[32]

It is apparent now that Fred had no intention of having the surgery done. He went to see Dr. Fox primarily to appease Randolph. Fred vowed after the 1938–41 hospital experiences that he would never be operated on again, and the thought of having to go through another such experience was too much for him.

On January 7, 1950, Fred woke up and began work on the *Last Stand.* He moved toward the front door to go out and as he did collapsed under severe pain. He was taken to the couch, but when the pain continued, and he became short of breath, the family rushed him to Jefferson Memorial Hospital in Mount Vernon where he died of shock on the operating table two hours later. The incisional hernia, which was the intestine protruding through the lining of the stomach wall at the point of the incision in 1938, had grown over the years until it resembled a football in size and shape. The pain he felt came from the constriction of the blood vessels in the intestine. In the past, by pushing the hernia in, he was able to relieve the pain. Evidently he was unable to do so this time and the blood supply was permanently cut off. Howard Deason was correct, had Fred not eaten so much, the protruding intestine would not have been so large and the hernia possibly smaller or nonexistent.

Fred was one month short of his fortieth birthday. He is buried in Prairie Knob Cemetery in Waltonville and rests between his mother, who died the following year, and his father who died in 1957. He separates his parents in death as he had so often in life.

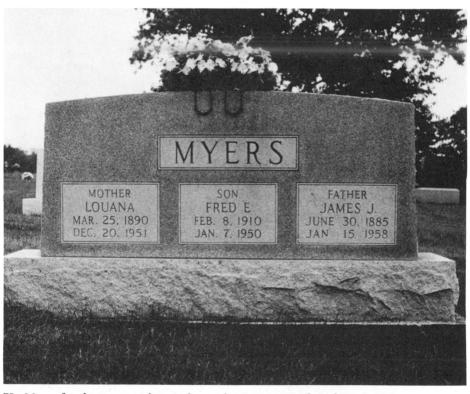

59. Myers family grave marker. Left to right: Louana, Fred, and James Myers

ART

Artistic taste in America changed in the 1930s. Between the world wars there was a feeling throughout our country that could be called Americanism, and which favored representationalism in art. This attitude prevailed except in that bastion of internationalism, New York City. There, just the opposite was true. Anything that smacked of Americanism was considered provincial, even backward. Taking their lead from New York, artists, critics, museum personnel, and art educators across the nation scorned representationalism in art. This attitude of extolling the virtues of European abstract art forms at the expense of native American art dated back to the Armory Show of 1913. It was this same snobbish internationalism that local artists were expressing when they ignored Fred Myers's carvings back in the early 1940s. They turned to the East, specifically to New York, and paid homage to the dictates of that city.

However, there were artists such as Thomas Hart Benton, Grant Wood, and John Steuart Curry who revolted against this strong international, abstract, trend in American art. Their style and choice of subject matter were quickly branded regionalism, and in Benton's own words, regionalism meant:

> in everyday American a "hick" movement. As such, however, criticism boomeranged and what was meant to slaughter us helped draw to us a national attention and

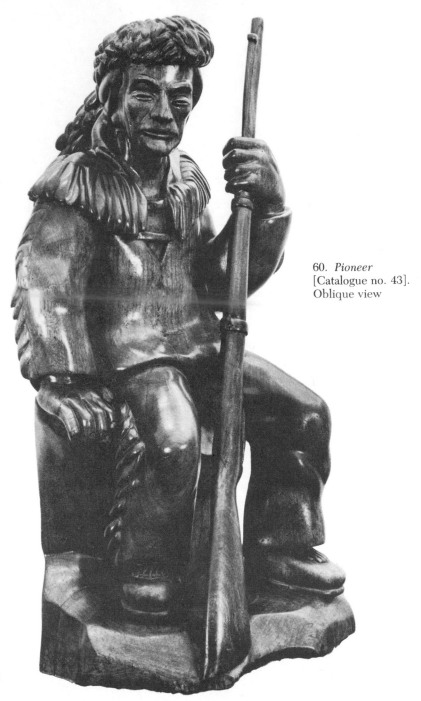

60. *Pioneer*
[Catalogue no. 43].
Oblique view

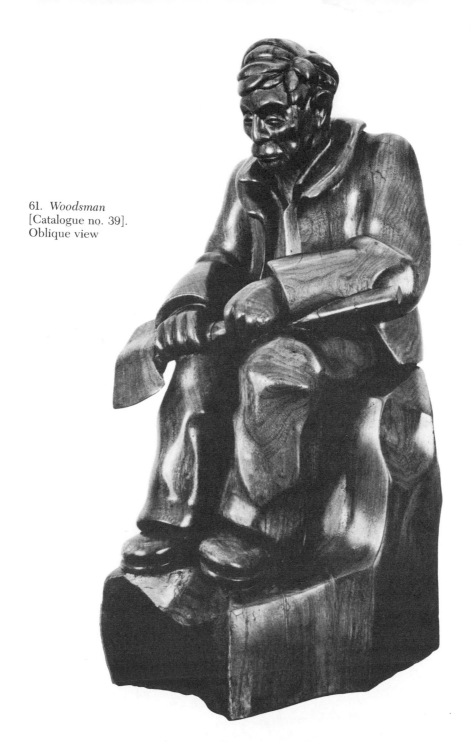

61. *Woodsman*
[Catalogue no. 39].
Oblique view

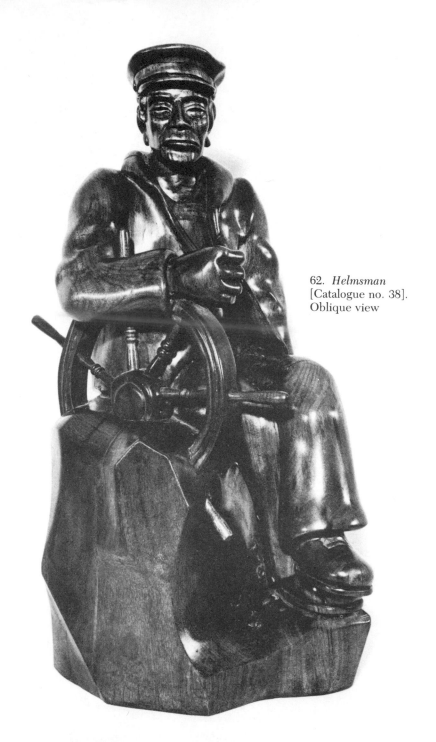

62. *Helmsman*
[Catalogue no. 38].
Oblique view

sympathy. We came in the popular mind to represent a home-grown grass-roots artistry which damned "furrin" influence and which knew nothing about and cared nothing for the traditions of art as cultivated city snobs, dudes and *ass*thetes knew them.[1]

Whether Fred Myers was aware of it or not, his art exemplified this movement called regionalism or "American Firstism."[2] One series of figures Myers did for the Southern Illinois Normal University Museum included a *Pioneer*, a *Woodsman*, and a *Helmsman*. With this theme of local, southern Illinois types, he shared the ideals of regionalism.

The particular American style of art identified as regionalist created a great deal of confusion. Regionalism was supposed to segment the United States into areas where one could identify particular styles of art. But there never was an easily identified style that was peculiar to a specific section of the country. Even when the term was applied to specific individuals such as Benton it was used more as an indictment rather than as a descriptive term explaining the way he painted. Regionalism was not meant to represent Benton, for example, as someone whose art could be understood and appreciated only in Missouri. Rather, regionalism was a term describing the apolitical nature of the art of the Midwest.

Other artists were trying to strike out at the injustices they felt abounded in America. This sort of social protest art would not have held any interest for Myers, Benton, or Wood. These artists were more intent upon ignoring the depression in America and preferred to deal with an art that was based upon a fundamental precept in the Bible-belt areas: man is measured by his productivity. In Benton's own words:

> Wood, Curry and I thought of ourselves simply as American or Americanist painters, sectional at one moment, national and historical at others. If we dealt largely with "agrarian" subjects, it was because these were significant parts of our total American experience. Surely man and the earth were not so new to art that our returns thereto needed a special name.[3]

Despite the distracting label, regionalist success was widespread. It was a populist movement that, even when the average citizen did not agree with the artists' imagery, he at least understood it. "The fact that our art was arguable in the language of the street, whether or not it was liked, was proof to us that we had succeeded in separating it from the hothouse atmospheres of an imported and, for our country, functionless aesthetics."[4]

To evaluate Fred Myers's work on its own merit and for its regionalist implications, his carvings need to be divided into two broad categories. One includes those pieces that were done on demand by Southern Illinois Normal University during the time Fred worked for the WPA. This group includes three classifications: the early prehistoric horses, a group of prehistoric animals, and the folk figures. All of his remaining pieces fall into the second category which includes three classifications: the pre-WPA presidential series, those pieces done during the WPA period but not carved specifically for the university (this group, which includes, among others, an *Archer*, a *Mantel*, many pipes, and numerous gunstocks), is made up solely of carvings done for an evening's entertainment at which time he gained his reputation for carving with a hawkbill knife. In point of fact, Myers was provided with professional wood-carver's tools while he worked for the WPA, and he used them and home-made tools, on almost all of his monumental works. In public, however, he whittled minor pieces with his hawkbill knife. Finally, there are the post-WPA pieces which include the prehistoric head, and the mounted *Last Stand* Indian Myers was working on at his death.

When Myers dealt with the illustrations of prehistoric animals supplied by the university, the quality of his carving and his ability to transpose form was clearly hampered. His creative energies were obviously suppressed by the demands of producing such subjects as a *Trachodon* or a *Stegosaurus*, as well the demand that they be as true to life as possible. Myers tried to fashion these images in the round based on flat two-dimensional drawings that revealed only a single view. The illustrations weren't always accurate and often additional drawings were necessary. Nevertheless, this experience reflected Myers's ability as a sculptor to

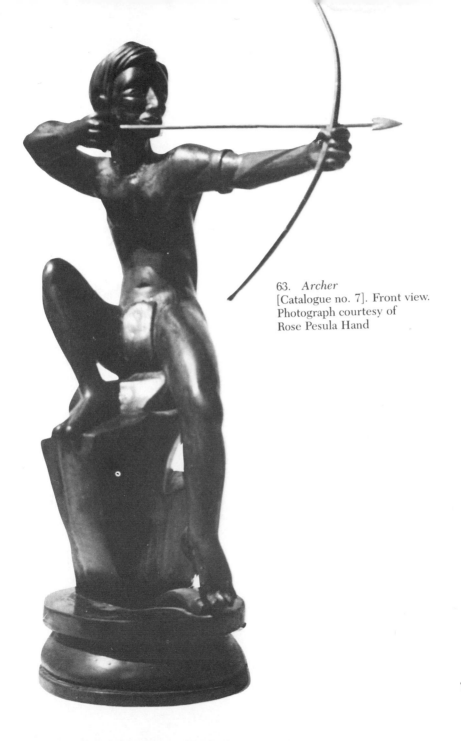

63. *Archer*
[Catalogue no. 7]. Front view.
Photograph courtesy of
Rose Pesula Hand

64. *Mantel*
[Catalogue no. 36]. Front view

create form and volume from something flat and two-dimensional.

Myers revealed his own personal interest in subject matter with the human figures. He was able to choose what he wished and was also allowed to alter them in what clearly became the Myers style. He no longer had to worry that "it's got to be this way or else it's just no good."[5] He now had the kind of flexibility that allowed him to interpret form as he saw fit.

The Myers style can be divided into two parts: subject matter and stylistic interpretation. Myers's subjects reflect his love for people and particularly those who labored and toiled for their living. He was able to capture in his carvings the customs and feelings of average, hardworking people. Subjects such as the *River Rat*, *Helmsman*, and *Woodsman* re-

flect his insight. Thus by depicting these people in action, he captured the character of rural America in the 1930s.

Even when we consider his early series of presidents, we find that he chose men like Lincoln and Grant who have always been associated with the soil, and Jefferson's agrarian philosophy clearly places him within this group. Lincoln, of course, symbolizes the entire state of Illinois and the three, possibly four, carvings of Lincoln acted as a focal point for Fred's presidential series. The youthful *The Myers Lincoln* who rose in the

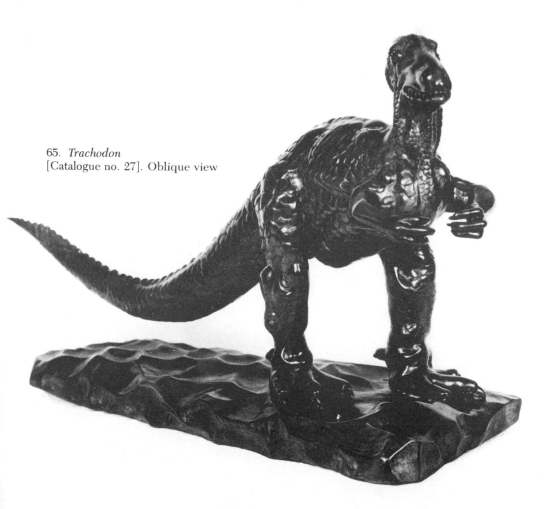

65. *Trachodon*
[Catalogue no. 27]. Oblique view

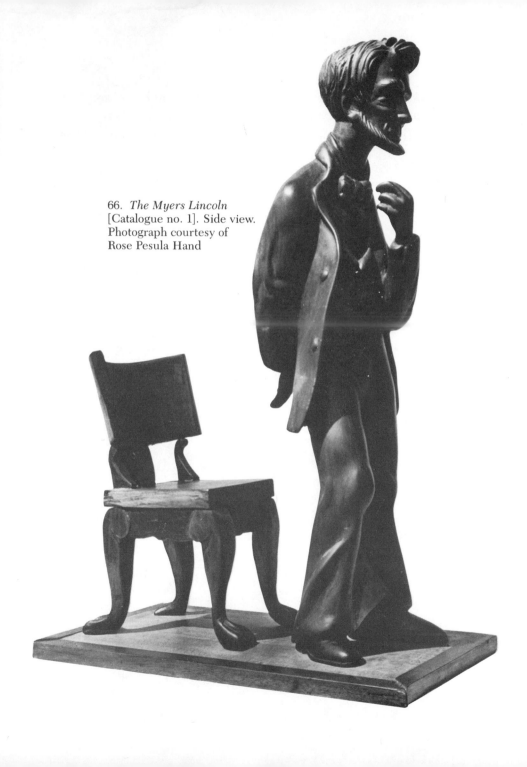

66. *The Myers Lincoln*
[Catalogue no. 1]. Side view.
Photograph courtesy of
Rose Pesula Hand

world of politics was a former rail-splitter and is carved from a railroad tie. *The Warren Lincoln* seems to have been patterned somewhat after Daniel Chester French's statue for the Lincoln Memorial. Myers's figure, however, is relaxed and appears to be smoking a pipe. The Southern Illinois University at Carbondale *Morris Library Lincoln* leans away from his chair as if he were lecturing or gesturing to an unseen admirer or making a point to somebody during a debate on the right side of the platform.

Most of these figures are the kind of folk heroes that are often talked about on the elementary and early high school levels. In a young person's life they make a profound impression. Myers's carving of the *Grant on Horseback* depicts the general atop his charger, pausing on a grassy knoll, and looking back over his shoulder possibly at the aftermath of a recent battle. Grant was particularly significant to the southern part of Illinois. As a general of the Union Army he took charge of the staging area at the confluence of the Ohio and Mississippi rivers, which held the state of Illinois for the North.

As previously noted, regionalism is undefinable except in the broadest of terms and no one would mistake Myers's carvings for the equal of Benton's paintings. But there is the strong compulsion to bind the two artists in their unswerving devotion to America and American themes. Myers's carvings appear to represent a conception and not an accurate rendering of a specific individual. When Myers carved the *Coal Miner*, he recorded his own feelings about a subject that meant a great deal to him. The same is true when he carved a figure such as the *Farmer with His Dog*. He reflected through his carvings his own time and place.

Did Fred Myers study the works of Benton and the regionalists? It is now apparent that Rose Pesula Hand, an early friend, introduced Myers to Benton's work. She writes: "I graduated from Carbondale with a major in art. Went on to study at the Chicago Art Institute. Thomas Hart Benton? Yes. Through me. I was interested in Curry, Benton, Joe Jones, the whole Regional bit at the time, and I collected every print, newspaper and magazine reproduction I could get my hands on. I could have shown them to Fred."[6] Even if Hand hadn't introduced Myers to Ben-

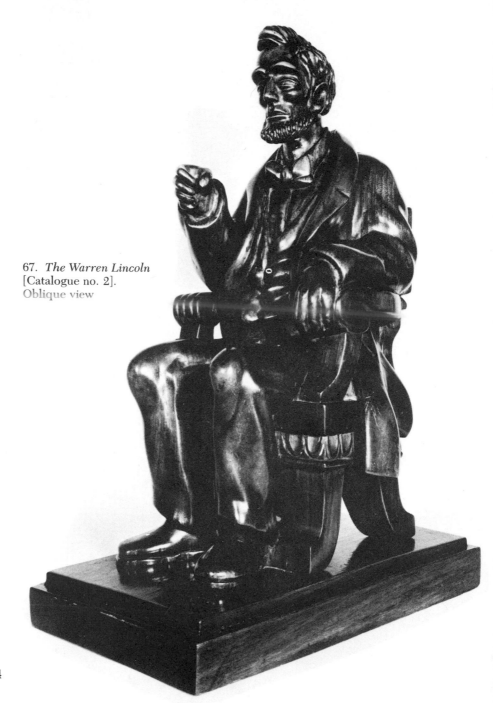

67. *The Warren Lincoln*
[Catalogue no. 2].
Oblique view

84

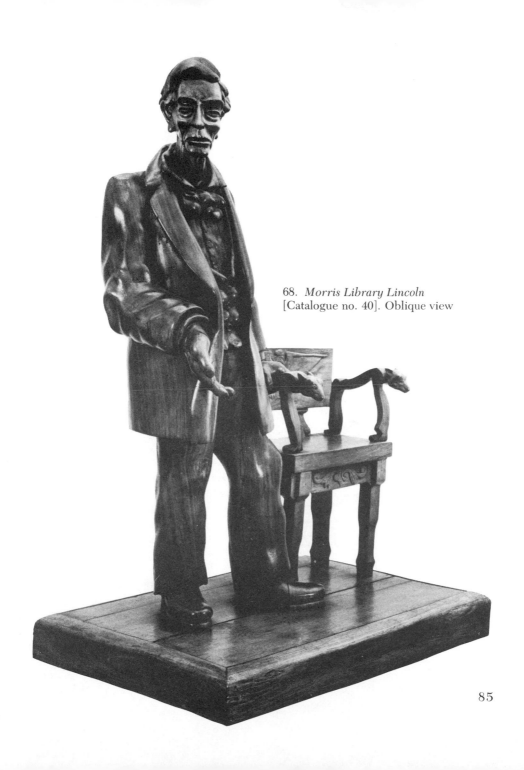

68. *Morris Library Lincoln*
[Catalogue no. 40]. Oblique view

85

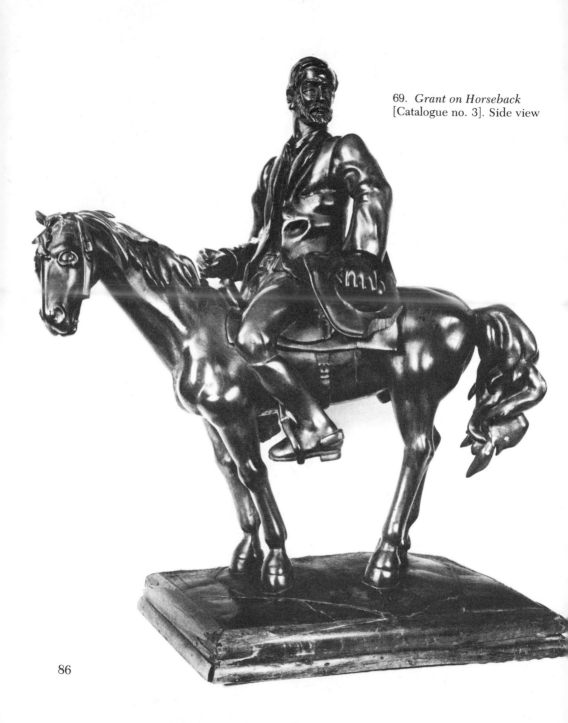

69. *Grant on Horseback*
[Catalogue no. 3]. Side view

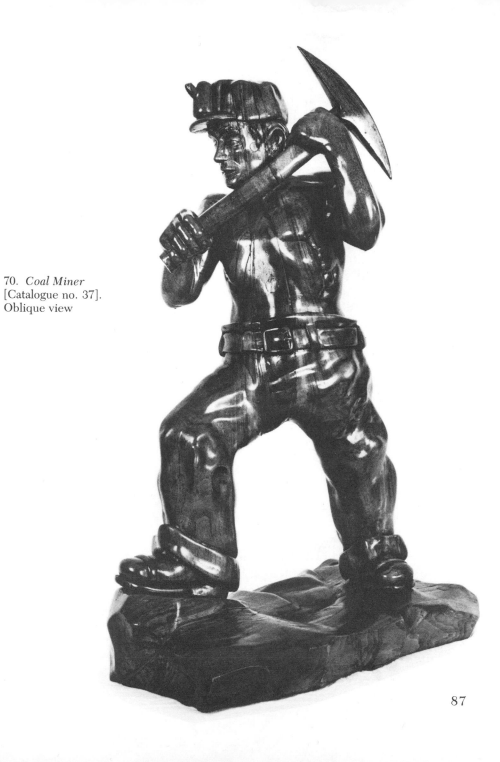

70. *Coal Miner*
[Catalogue no. 37].
Oblique view

87

ton's work, Benton was at the height of his fame during this period and he had completed his Indiana murals to high acclaim and was receiving broad public attention. His paintings were reproduced in the gravure section of Sunday newspapers across the Midwest.

Like Benton, Myers captured an American form by the disjointed rhythms, bulging muscles, and rubbery sway of his figures that suggest the presence of great activity. In the *Farmer with His Dog*, the similarities between Benton's and Myers's styles are too alike to be accidental. The rhythmic movement of the torso; the mustachioed face and tall crowned hat are typical of Benton's field hands, as in his *Cradling Wheat*. Almost all of Myers's pieces depict some kind of action. The *Farmer with His Dog* appear at leisure, but with the hoe (there originally was a hoe in the farmer's outstretched right hand) the farmer becomes an active, toiling individual. Without it, he's out for a walk with his dog. Myers seems to be able to capture the customs or feelings of hardworking people because he shared their experiences.

An even further bond between the two artists can be found in the drawings Benton made in which he treated the images somewhat as "maps" of form. They were, in this respect, somewhat like sculptor's drawings. Most could be readily turned into sculpted forms, projected in clay or plastilene. Benton ran across an account of how Tintoretto proceeded in the creation of his famous *Last Supper* in the church of S. Giorgio Maggiore in Venice. Tintoretto had made small sculptures to work out the positions of the figures and gave them a logical and realistic light and shade. Benton began experimenting with a sort of dioramic sculpture in high relief. And in the winter of 1919–20 he wrote: "I would make many changes in the future, but from this time on they would all possess a certain stylistic continuity, imposed by constantly thinking in terms of a three-dimensional sculptural process. This would eventually come to affect even my studies from real life. I would come to draw people and landscapes, even fruits and flowers, much like sculptural carvings."[7]

It appears that rather than Myers emulating Benton, it was Benton who from the beginning of his painting career emulated a sculptural point

of view. But in the final analysis Benton was a trained professional destined to create major works of art. He was a college-trained artist who had studied in New York and had a national reputation. Fred Myers, on the other hand, had no intention of creating art with his wood carvings. Nevertheless, he succeeded. This has to be one of the most surprising aspects of his work. He succeeded despite the lack of a sculptor's mentality. In the true sense of the word, he really wasn't an artist. He didn't have an artist's sense of tradition or of wonder. Neither did he experiment or seek out information that would increase his own knowledge and allow his art to grow. All those characteristics that we normally associate with an artist, Myers lacked, all except one—pride. He did have the artist's sense of pride in accomplishment. Jack Batts remembers going out to the Myers farm and Fred would bring up a new piece he had just finished and place it on the dining room table for Batts to see. We have also learned that he displayed his pieces wherever his friends hung out. From Mondino's poolroom to Tolluto's tavern to Surgalski's food store to the mine in Waltonville, Fred would display his work for his friends to see. But we believe it was particularly important to get Batts's approval because he was a sculptor, an artist. Yet he felt uncomfortable in the presence of artists, and he neither understood what they had to say nor contributed anything of an aesthetic nature to their conversations.

What is it then that makes Fred's carvings art? It is most likely the carving process itself. Many primitive tribal cultures, the Ebon society for example, use the word *art* as a verb rather than a noun. This difference in emphasis places the importance on the act of doing rather than on the result. And surely Fred was "arting." He gained his greatest personal enjoyment out of the carving process, and if a piece did not measure up to his own sense of what was acceptable, he heaved it on the wood pile for burning. Similarly he destroyed all his preparatory drawings. Those finished pieces that he admired might be given away, if he liked you; or just as easily, they might end up as a door stop.

This idea of Fred being concerned primarily with process is consistent with the general nature of a naive or primitive artist. But this label doesn't square when applied to Myers's finished pieces. A naive artist

usually works in a fashion consistent with his limited understanding of process. A trained artist relies on a total understanding of medium. Their goals might be the same, but the disciplined artist invariably comes closer to success. We appreciate the work of the naive artist in the particular way he has failed in reaching his goal.

> Now this is one of the things that Fred did not know. And most primitive people wouldn't know it. They work in wood, but they don't use it like wood should be used. Wood should always be used in a massive form. Massive. Always remembering that this is a fragile substance I'm working in, in order to keep it and save my work, that I must do it without losing what they want to get. Fred could. He was one of the fellows that could do it.[8]

Perhaps Myers is the primitive artist after all; untutored in the formal aspects of art, but possessing an uncanny intuitive capability. If such is the case, then any number of men would have been able to do what Myers did. This would be true if all we appreciated was his truth to nature. But there is much more. First, there is the deep appreciation for the wood itself. He did not use just any type of wood, but he chose black walnut, a wood that when polished displays a deep, dark richness of grain. Jack Batts commenting on his selection of wood observed,

> And of course everyone loved his work. For one reason because it was always shiny. You know like a pet coon the average American thinks if it shines it's good—I admired the finish that he did, and it was a part of his style of working. Fred's work would not have been Fred's work without that high polish on the black walnut; and the reason he did it is because he just loved wood. Black walnut to him was like a lot of people carrying around gold pieces in their pockets. Fred was a wood man. He loved wood.[9]

It's understandable also that Myers should choose a subtractive medium such as wood. It didn't take sophisticated tools to carve. His

hawkbill knife and bits of glass for smoothing were sufficient. Later he graduated to more professional tools when he worked for the Southern Illinois Normal University Museum. He never painted any of the figures nor did he ever put varnish on them. He preferred Johnson's Wax. The final process was important to him even to the point of being compulsive. After using finer and finer grades of sandpaper, Geno Casagrande and Ralph Murray would simply use paper to smooth out the grain and then apply Johnson's Wax.

To see Myers's carvings is to appreciate his understanding of materials. In the carving process, Myers retained a constant respect for the natural growth of the wood, and he never violated its mass, grain, or rhythmic feeling. This is why the discovery of Myers's *Last Stand* is so fortunate; not only because it was the last piece upon which he worked, but particularly since it was left incomplete. With this carving, we get a firsthand opportunity to see how Myers worked the wood.

From the very point of choosing the proper stump, his uncanny, intuitive eye was at work. Scrutinizing the surface, looking for flaws, checking for burls, all of this took time. But once he had decided on a piece, he was unrelenting until the image began to emerge from the root-ends and stump. He never imposed upon the wood a design that was incompatible with its shape. The key factor is that he could visualize how the finished piece was to look. This has been confirmed by many of Myers's friends. Jack Batts recalls, "He had a way of seeing things that most people are born without, simply never are able to visualize these things."[10] Rose Pesula Hand remembers:

> I watched him work one time when he was teasingly refusing to say what it was going to be, I said: "Fred, I get the feeling that your subject is really there and all you're doing is taking off the outer coating. Otherwise you wouldn't know when to gouge deeply or when to skim the surface." He smiled and agreed: "Yes, it's already there. I feel it. I know it as soon as I pick out a log."[11]

Fred was an excellent card player. The game he played was pitch, and it demanded a tremendous amount of concentration to know where the

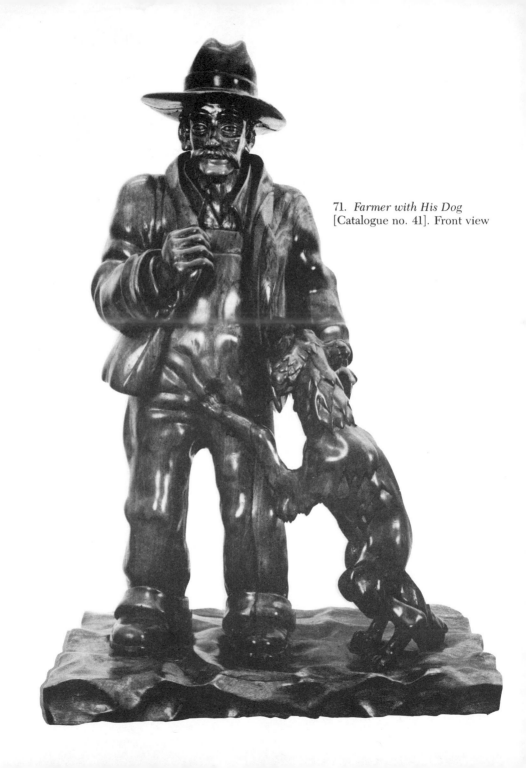

71. *Farmer with His Dog*
[Catalogue no. 41]. Front view

cards were. That is the concentration that Fred used when he was carving. This same concentration that earned him a few dollars in a card game, allowed him to flail away at a wood stump seemingly at will. But in reality he had locked into his mind exactly the kind of image he was looking for and nothing could separate him from his goal.

Fred wasn't always unerring in his carving. All of his mistakes, and Geno relates that there were quite a few, have gone up in smoke. Only one survives as a completely different subject than originally planned. The *Helmsman* was originally planned as a seated coal miner, but somehow the hat didn't come out correctly, and so Fred altered the entire piece. Normally, he wasn't interested in saving anything that missed the mark, but in this case he must have believed that there was something worth saving.

It appears Myers was uneven in the way he proceeded as shown in the *Last Stand* Indian. Almost like a child in his excitement over getting to the toy in a Cracker Jack box, Myers would begin roughing in the entire piece and then work down to a finished surface on a particular area. The size of the cutting marks left by the chisels reflect this shift in attack. While he attempted to avoid burls whenever possible, he was not intimidated by them. Cutting into a burl could have devastating results and Myers knew it. Being a knotty, gnarled area, cutting into its surface frequently released tension in the wood grain, and caused cracking and drastic changes in grain direction.

Also unique is the fact that Myers worked with only a single figure. Nowhere in his entire output is there a piece with more complexity. His interest in sculpture or his aesthetic sensibilities did not transcend the single figure except possibly the carving of the *Farmer with His Dog*, but even there it's a minimal intrusion. The farmer is not responding to the dog as much as he's paying attention to the landscape. In some instances there are props such as in the *Helmsman* with the great wheel, or the *River Rat* with his net, but always the focus is upon the single character. Similar to the prehistoric cave painters of Altamira and Lascaux, Myers isolated his figures to instill them with monumentality. Nowhere do we find baroque complexities of composition.

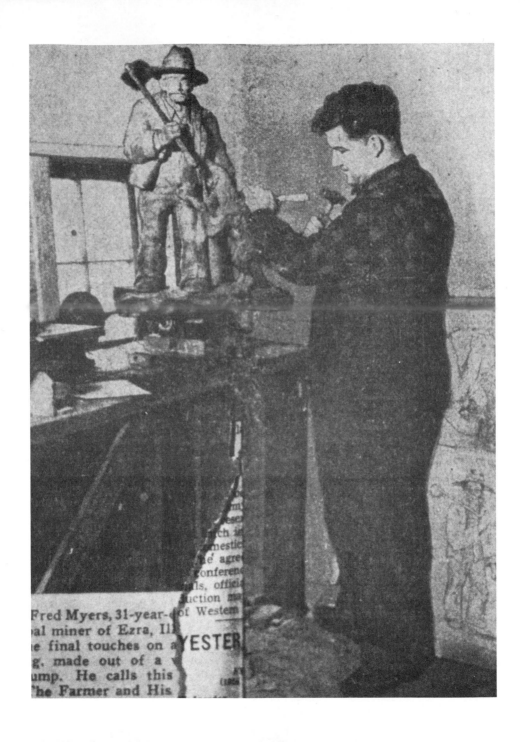

Fred Myers, 31-year-of Western
al miner of Ezra, Ill
e final touches on a YESTER
g, made out of a
ump. He calls this
he Farmer and His

72. Fred Myers working on the *Farmer with His Dog* with preparatory sketches shown in lower right-hand corner. Photographed by C. William Horrell of the Department of Cinema and Photography, Southern Illinois University at Carbondale. Appeared in *The Chicago Daily News*, February 27, 1941, reproduced by permission of the photographer and Field Enterprises, Inc.

Along with this preference for the solitary figure is the frontal nature that most of the pieces exhibit. Like their tribal counterparts they face us directly. All that we need know and understand is there before us. Myers's statement is simple, direct, and forceful.

These same figures also display a high degree of arrested energy which is bound within the walnut core. This feeling is heightened by a somewhat compressed pose and frontal point of view all contained within the

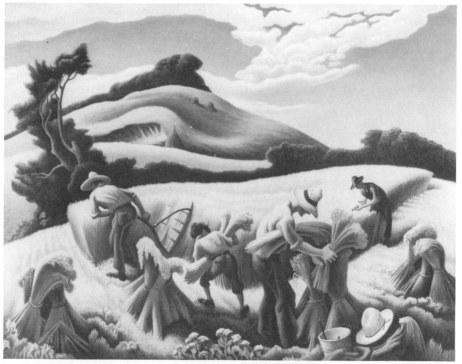

73. Thomas Hart Benton's *Cradling Wheat*, 1938. Tempera and oil on board. Courtesy of The St. Louis Art Museum

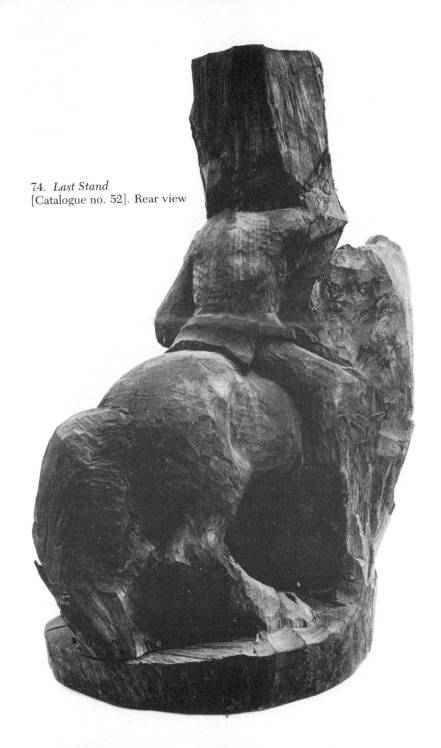

74. *Last Stand*
[Catalogue no. 52]. Rear view

75. Alberto Giacometti's *Hands Holding the Void*, 1934–35. Bronze. Courtesy of The St. Louis Art Museum, Friends Fund

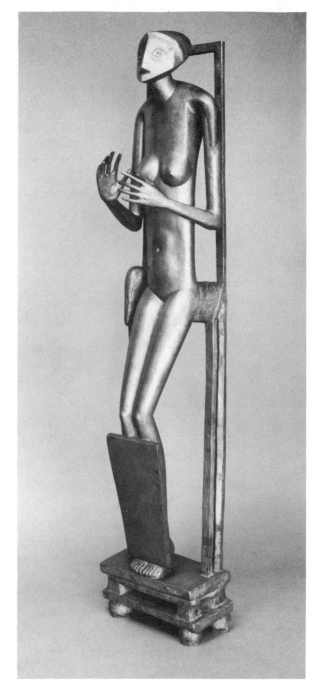

projected circumference of the stump of wood. These figures seem to yearn to burst forth from their confinement. This observation is particularly true of the series of Southern Illinois types. The *Woodsman*, *Pioneer*, *Helmsman*, and *River Rat* all have these same traits. They all represent single figures, display frontality, and contain a feeling of compressed energy.

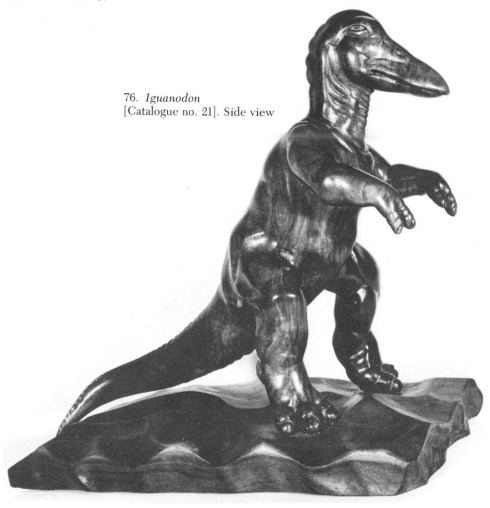

76. *Iguanodon*
[Catalogue no. 21]. Side view

77. *Triceratops*
[Catalogue no. 28]. Side view

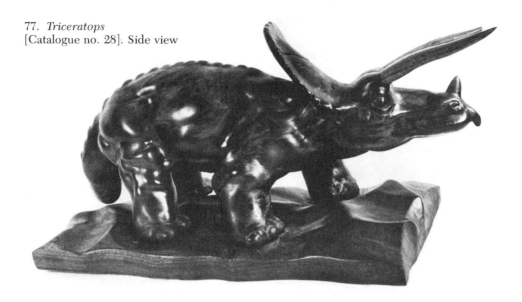

By confining the figure within the stump, a spatial restriction is imposed on the viewer much as with Giacometti's figures that exist within a spaceless void, *Hands Holding the Void* being a prime example. It is as if Myers's figure begs to be touched. Yet, the viewer is unable to penetrate the shell, the "force-field" that is imposed by the stump's circumference. In this way Rose Pesula Hand's comments dealing with Myers's loneliness and isolation can also be seen as illustrated in these pieces. Other carvings such as the *Grant on Horseback*, *Jefferson*, and many of the prehistoric animal carvings reflect no such confinement. The use of root-ends extend elements beyond the circumference of the stump.

In looking at the entire collection of carvings, it is also fascinating to see how well Myers integrated the figure with the base. The *Morris Library Lincoln* has planklike floor boards for the base and the *Farmer with His Dog* has an undulating surface representative of a plowed field. The *Iguanodon* and the *Triceratops* also display an undulating surface reminiscent of the earth.

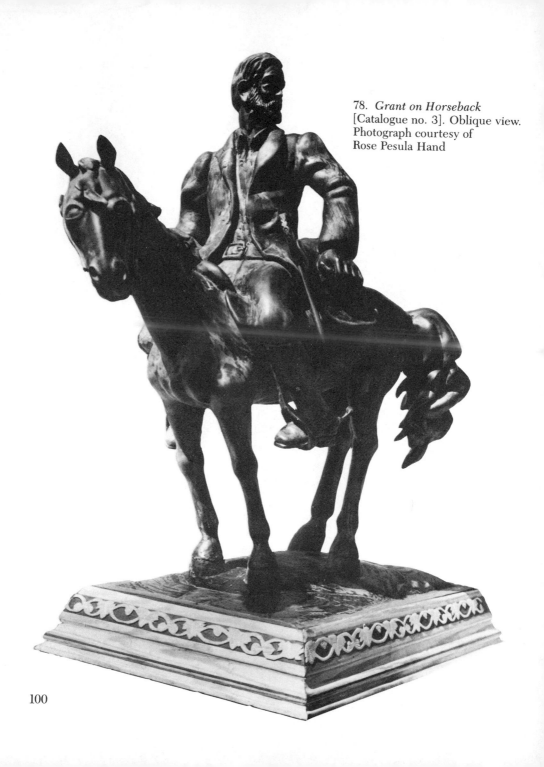

78. *Grant on Horseback*
[Catalogue no. 3]. Oblique view.
Photograph courtesy of
Rose Pesula Hand

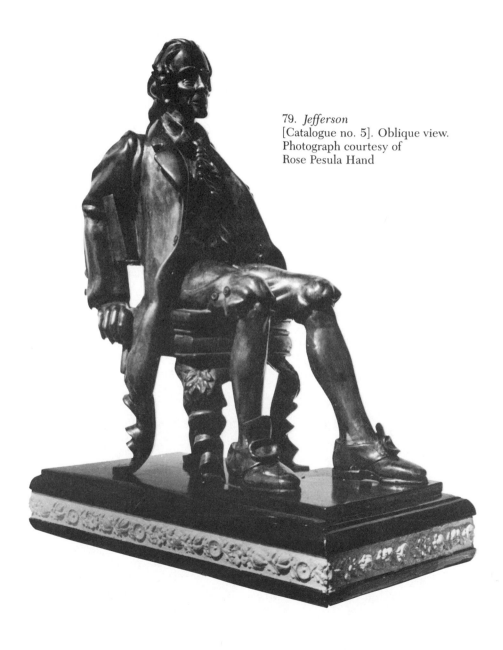

79. *Jefferson*
[Catalogue no. 5]. Oblique view.
Photograph courtesy of
Rose Pesula Hand

Photographs, taken by Rose Pesula Hand in the late 1930s, of Myers's *Grant on Horseback* and the *Jefferson*, reveal greater detailing of the bases than now exists on either piece. All of this seems to point to the fact that Myers was deeply concerned with the integration of figure and base. Some carvings, such as *The Myers Lincoln* and several prehistoric animals, have been bolted to their bases. Whenever possible the two elements of figure and base are carved as a single piece, maintaining Myers's obsession with not adding wood.

In the final analysis it appears that Fred Myers looked upon each carving as a unique challenge. An early piece, but one of his best, the *Grant on Horseback* reflects his consummate skill with detail. Grant is bedecked with a minute detail of dress, with his charger and reins all

80. A United States three-cent stamp issued in 1932

lovingly reproduced. Nothing escapes Myers's penetrating eye as even the rotating rowels within the general's spurs are cut from the single walnut stump. The face of Grant is also personalized. It was fashioned from a three-cent stamp issued in 1932 which depicts Sherman, Grant, and Sheridan. On the other hand, Myers's animal figures seem at times stylized and almost distorted.

Thomas Craven, an American critic writing during the thirties reflected in his book *Men of Art* that: "If the mechanized United States has produced no plastic art of any richness or vitality, it is because she has borrowed her art from foreign sources and refused to utilize the most exciting materials that have ever challenged the creative mind."[12] Those

"exciting materials" he referred to are the native American experiences. Spokesman for the regionalist cause, he put into words what they were putting down on canvas. Fred Myers's carvings are unique because Myers was a product of his time. His art reflects his personal view of life—the substance upon which American art thrives. As Thomas Hart Benton stated: "As long as men live in different physical environments and keep their linguistic inheritances, basic cultural diversities will survive. If, however, art insists on ignoring these for a set of purely aesthetic universals, it is going to produce only a universal academy."[13]

THE SEARCH

In the course of our research, we have been asked on numerous occasions why we undertook such a project. Our constant response has been the interest we share in Fred Myers, the man and in his art. At the bottom this is true, but there is more to the story than that.

We now realize that we should have undertaken this work years ago. We were both aware of Myers's work, but we believed that everyone else was too. Our first hint that this was an incorrect assumption came when we began to find conflicting accounts of his life. One article began by stating that Myers was born in Wales and died thirty-seven years later. Another spelled his last name Meyers and claimed that he died at the age of thirty-eight. The discrepancies began to bother us, and later we were to discover that Fred's brother Raymond was also concerned about the inaccuracies. Therefore, when we decided to undertake this book, we were most concerned with setting the record straight about Fred Myers, before too much time intervened and no one remembered the truth.

While we were still deciding whether or not to get involved with the project, another fact appeared. The carvings owned by the Southern Illinois University at Carbondale Museum and Art Galleries constituted the bulk of Fred's work as we understood it, but it specifically covered only the three-year period 1939–42. What had become of the carvings that surely preceeded the WPA years, and more importantly the years from late 1942 until his death? These two puzzles initiated our odyssey and took us down many blind alleys.

Our first experience was such a disaster that the entire project might have been abandoned at that point had it not been for the warm reception we received from Harold Mitchell. June 28, 1978, proved to be an inauspicious beginning to our adventures. Arriving at 411 West Chestnut Street in West Frankfort, we knocked on the door expecting to meet Mr. Harold "Barber Mitch" Mitchell. Instead, Mrs. Ina Bruce answered and in the course of our conversation said that she had the prehistoric head done by Fred, and she invited us in. We talked about the proposed book with her. She asked if we were from Benton, Illinois, which at the time did not make sense to us. We discovered later that a reporter from the Benton newspaper had obtained information from Mrs. Bruce and then misquoted her in an article about Fred. She would not let us photograph the carving, insisting that she was preserving Fred's memory. She then pointed out that the "Barber" lived next door. Evidently the house numbers we had been given proved to be inaccurate. Added to our poor beginning that day was: 1) an incorrect address to the Myerses' Waltonville home; 2) A. W. Modert, the doctor who had operated on Fred in 1950 and could have supplied us with invaluable information, had just died; and 3) Jefferson Memorial Hospital, where the surgery on Fred was performed, had no record of that surgery. We almost ended our search on the very day we began it.

After our unsuccessful first day, things began to pick up and one of our first major discoveries was that Fred did not do that many major figures of the size and quality of the *Grant on Horseback* or the *Farmer with His Dog*. Several of Fred's major pieces may be lost, but he probably didn't do all that many. Important pieces took him from ten to eighteen months to complete, except those done for the university museum when he was working full-time and was pressured into completing a piece within a month's time. People claimed he was prolific, but they only saw him at work on carvings done in the local taverns or in Mondino's poolroom, possibly thirty or forty such pieces being completed. The major sculptures were done at home and sandwiched between working in the mine or at odd jobs. We can identify most of the pieces done between 1929 and the point he began working on the WPA. From 1942 to 1948 by his own

admission he did little carving. He did two major pieces, the *Cro-Magnon Bust* and the *Last Stand*, between 1948 and his death. Of all the people we've interviewed, no one has mentioned a new, and heretofore unknown sculpture.

We have dispelled the notion that Fred only worked with a hawkbill knife that so many people have told us about.

> Fred was one of the greatest guys in the world. He could take his hand and put it in his pocket and he had a hawk-billed knife. And he could snap that thing out and have that blade open. . . . But most of the time he would come out and do that [snaps his finger], and when he snap that finger, they thought he would have that hawkbill. And he wouldn't have nothing. And he could make a finger snap sound like a gun going off on account of the toughness of his hand.[1]

But the fact of the matter is that this is how they saw Fred work, whittling away on a quail or pipe bowl or a pistol stock. In his studio he used professional wood carving tools and cut in some details with the hawkbill knife.

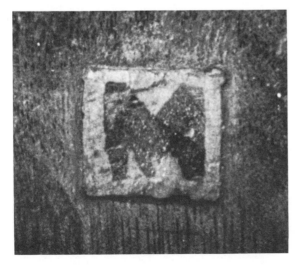

81. Inlaid *M*

The question of the initial *M* which appears on some pieces also posed an interesting problem. The *M* appears only on those figures done for the university museum and even here there are some inconsistencies. None of the pre- or post-WPA carvings have the *M*. Geno Casagrande was able to shed light here. "As far as I know he put them in. He might have missed some, but I always thought he got that white oak and a piece of walnut and he'd make the *M* then he'd put it in the oak."[2] But this did not explain why some of the earlier pieces and some of the final pieces, done while working on the WPA, did not have the *M*. The facts seem to be as follows: the idea for using the *M* did not materialize until after Fred had worked some months on the WPA, so those early pieces would therefore lack the *M*. Since the *M* was the very last thing done to a piece before it left Fred's hands, it shows a certain amount of pride in accomplishment on Fred's part. If he had time it was done, if not the piece escaped him before he could add the *M*.

Only one surviving piece, the *Hound*, exists to contradict this assumption. This piece was done during the WPA period, but not for the Southern Illinois Normal University Museum, and it displays the *M*. Everything about the piece is atypical and should not be considered a part of the other WPA work. First, it was done in white oak, a wood Fred did not work with very often. Only one other major piece, now missing, used white oak, a coal miner carrying a pail. Second, the *Hound* was done for a friend, but neither of them enjoyed the final product. In fact, Fred added a piece of wood, something that he abhorred.

He would rather destroy a piece than add wood. He added a new tail to the *Hound*. Why he would add an *M* to a piece neither man liked is somewhat baffling. (When Fred couldn't sell the piece, Moreau Maxwell bought it for $35.00.) A clue might be found in the placement of the *M*. Normally Fred placed it in some unobtrusive place around the back or in the base of the figure. Here it holds a more prominent place on the base directly beneath the figure of the hound, and directly in line so that the dog would urinate on it. "You know this is interesting . . . it has the *M* and also as Fred pointed out it is exactly where the dog is going to pee."[3] Could Fred have been chastising himself for such a bad piece, or could this have been Fred's attempt at an inside joke?

82. *Hound*
[Catalogue no. 31]. Side view

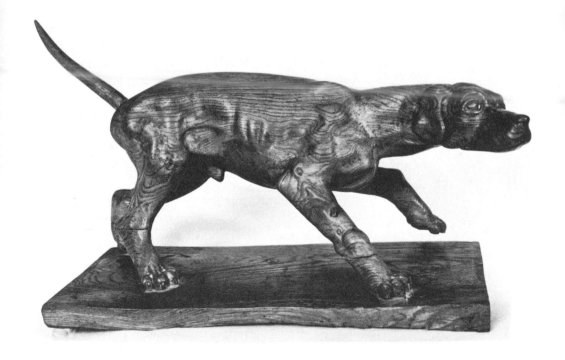

We must confess at this point that in trying to date Myers's carvings chronologically, a game most art historians enjoy playing, we were originally in error. When viewing pieces like the *Grant on Horseback* and the *Jefferson* the marvelous detail and distinct Myers styling seemed to place these as late pieces which were completed toward the end of his life and at the height of his talents. We were surprised to find that these pieces along with *The Warren Lincoln* were among his earliest efforts at the time he was interested in doing a presidential series.

Of course the most difficult thing in our search has been to locate missing pieces, those that have been spoken of during interviews but seem to have disappeared. Some we may never find. Others have been destroyed because most folks didn't think much would come of Fred and his art, and in one case the pain was too much to remember. On May 3, 1938, two girls ages seven and nine were boating with their mother on Old West Frankfort Lake. A storm came up and capsized the boat. The mother survived, but the daughters drowned. Fred had worked with Leonard Galloway, the father of the two girls, in the mines, and out of sympathy for the girls' deaths did two relief plaques with a portrait of each girl taken from family photographs. The carvings were exact to the details of face, hair, and eyes shut as if half asleep. Mrs. Galloway went out to the farm on several occasions to watch Fred carve, and Geno remembers that she rubbed her hands over the portraits many times. When Fred was finished he made a present of the plaques to the Galloways. Mrs. Galloway's grief was such that she found it difficult to look upon the figures of her children and hid the carvings rather than display them. Every time she came across them, it would reopen old wounds. Eventually she burned the plaques. Everyone who saw the portraits states that the resemblances were striking. This would support the contention that Fred could do portrait work when he chose.

On one occasion Fred did a portrait, in this instance of his brother Raymond, which was based on a service photograph (see ill. 44) and called the *Happy Soldier*. It was also a relief, and once again all that remains is the photograph upon which it was based. A *Sketch of a Cowboy* that does survive resembles Fred's lifelong friend Dan Bellini.

Whether this sketch was even meant to be a carving is not known. As we mentioned earlier, Fred loved to display his best carvings, and evidently the relief portrait of his brother was displayed in Barker's drugstore in West Frankfort for some time before it disappeared. Many objects, mostly minor in nature and including pipes, pistol stocks, early chalk drawings, and so forth, have been lost or destroyed. However, some major pieces that have been lost are worthy of note.

When Fred first joined the Southern Illinois Normal University museum program he did a series of horses. It is not known if he did nine horses of which four are missing (the university museum only catalogues five, but this cataloguing, the first of its kind, was done by William Johnson as recently as the early 1970s). Thirty years had elapsed since Fred did the pieces. Jack Batts also remembers a series of four tiny horses which may not be the same set that the university owns.

> But anyway about the little three-toed horses. Here he built these, and there he had them out on the table. And he'd put them out on the dining room table, you know, in the house when he got through with them. And if he knew I was coming out he would put them out there so I could see them. And here they were, beautiful little things. And I practically wept tears, you know, knowing that they wouldn't last. Just beautiful work and they wouldn't last. So this was [what] I was trying to tell Fred that maybe he should do these things in another medium.[4]

Geno Casagrande remembers distinctly nine horses in all. "There's supposed to be nine. Nine. . . . Well there is supposed to be nine. We made a whole series of horses because I remember we worked on Saturdays to get them all out. They wanted them right away. They had to have them right away, and Maxwell wanted them right away. He got to have them down there to display. Then Fred say, 'Well, let's take a couple days off hunting.'"[5]

Regardless, some figures *are* missing. An early inventory done by Fred Cagle lists three figures: a *Mastodon americanus*, a *Saber-toothed Tiger*,

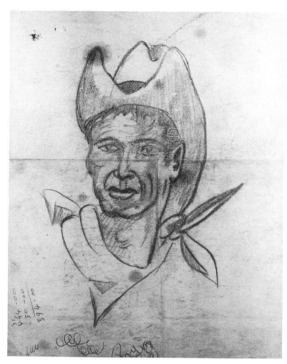

83. *Sketch of a Cowboy*
[Catalogue no. 35]

and an *Eohippus*, and of these the *Saber-toothed Tiger* was missing until recently. An inventory from 1942 includes: a *Coal Miner, Farmer with His Dog, Pioneer, Indian*, and *River Rat*, but there is no carving extant of the *Indian*. These pieces coupled with the missing four horses and at least five other pieces, a bust of *Lincoln*, a *Fisherman with Boat and Oar*, a *Brontosaurus*, a *Bear* (see ill. 33), and a *Glyptodon*, have all disappeared. What happened to them? The events surrounding the discovery of the *Saber-toothed Tiger* are worth mentioning. Victor Randolph, who presently owns the *Last Stand*, mentioned the fact that Bruce Merwin, the acting president of Southern Illinois Normal University from April, 1944, to December, 1944, had a carving in his possession.

84. *Eohippus*
[Catalogue no. 15]. Side view

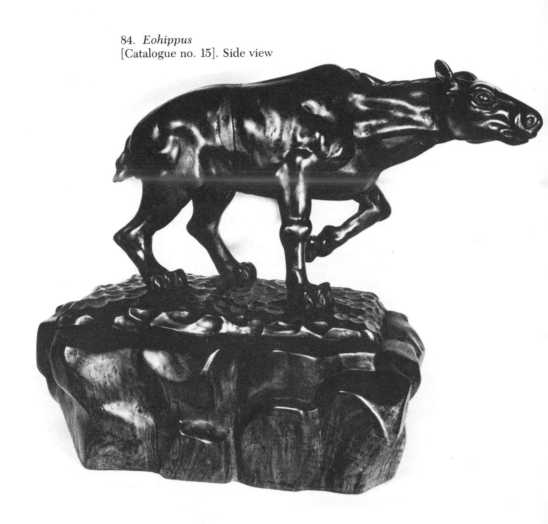

85. *Mesohippus*
[Catalogue no. 16]. Side view

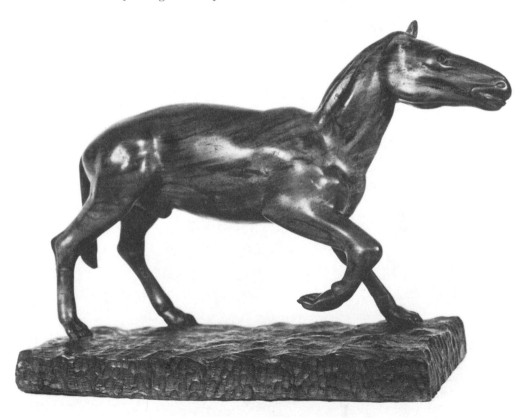

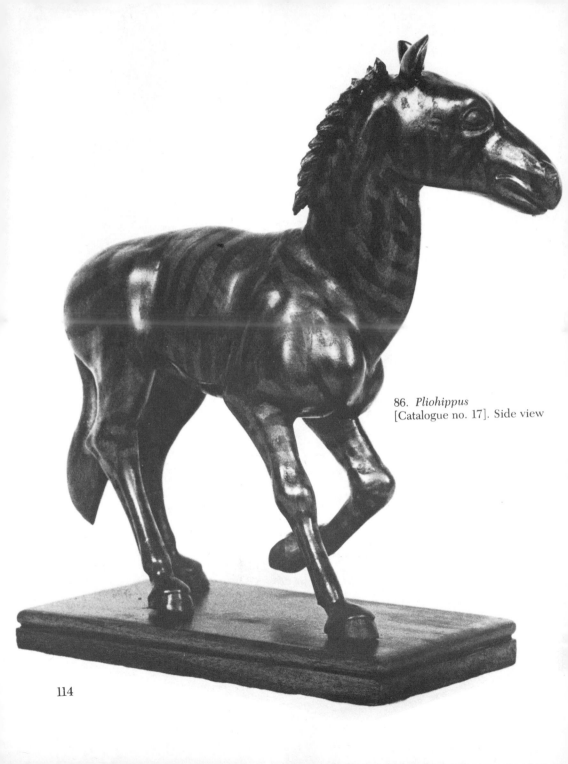

86. *Pliohippus*
[Catalogue no. 17]. Side view

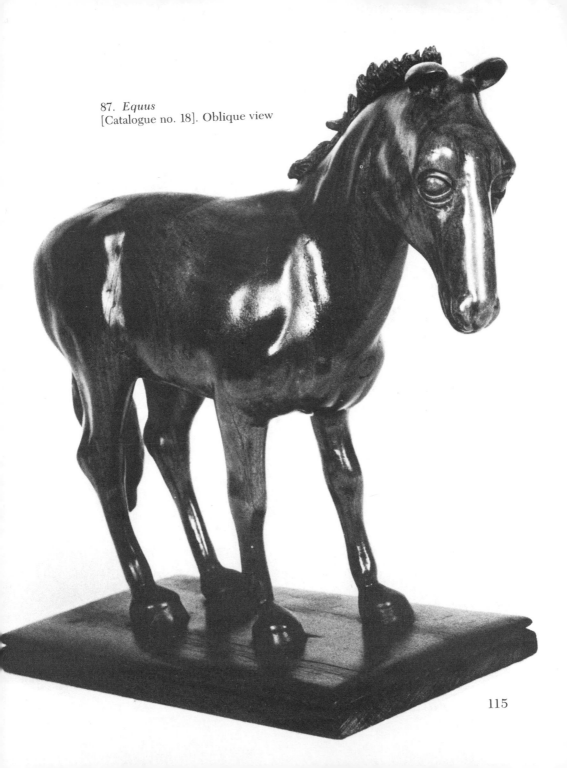

87. *Equus*
[Catalogue no. 18]. Oblique view

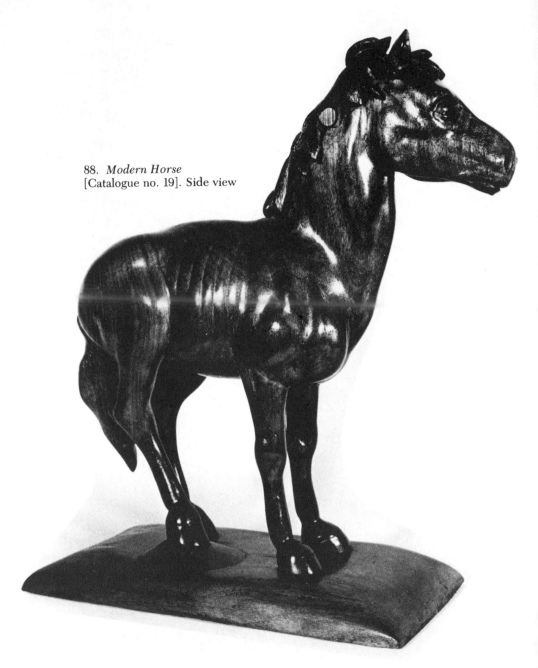

88. *Modern Horse*
[Catalogue no. 19]. Side view

"I think he [Bruce Merwin] told me his nephew picked up that *Sala-mander* [Randolph was incorrect; it was the *Saber-toothed Tiger*]. . . . That's right, he has some work down there he was telling me about. . . . I don't know whether it was taken from a copy or something or from some prehistoric photo."[6] We were puzzled because the *Salamander* was accounted for. But we decided that there might be a larger example of the creature, since Fred often made several starts before he completed a piece. A letter to Merwin, now convalescing in a Florida nursing home, revealed that he had possessed a carving, unidentified, but had given it to his nephew who was living in New Jersey. In contacting the nephew we found that the carving was not a salamander, but the lost *Saber-toothed Tiger* from Cagle's inventory of 1939. Not all of our prob-ings have proven so fruitful because additional pieces are still missing.

A letter from Thomas F. Barton to President Pulliam dated August 30, 1940, reveals a serious and chronic problem with security at the museum during the period that Fred worked for Southern Illinois Normal Univer-sity and may shed additional light on the missing pieces. Fred's concern over the safety of his pieces was verified in an interview with Ralph Murray. The letter deals with the problem of keys and access to the museum collection in the Parkinson building. "Last Saturday at 8 P.M. Mr. Peithman found a door unlocked leading into the Parkinson Labora-tory. He went up to the Museum and found that door unlocked. Wednesday night of this week he went up to the building to work on his collection and found the Museum door unlocked again."[7] This problem was also verified by Irvin Peithman in a telephone conversation. It is altogether possible that some of Fred's carvings were lost at this time.

It was through some luck that Ralph Murray happened to see our appearance on KFVS-TV, of Cape Girardeau, Missouri, which explored our search for Fred Myers's carvings. We visited him and found that he had replaced Geno Casagrande as Fred's assistant early in 1942. During this time Fred was shifted from the museum program to a Carbondale-based arts and crafts program for the state of Illinois. Ralph Murray identified six additional carvings (a *Mammoth*, *Standing Indian*, a *Farm Horse*, a *Man* and two others). He could not pinpoint the nature or

subject of the last two pieces, nor the subject of the "man" Fred carved. None of these pieces have been located. Ralph Murray also identified the woman who directed the project, but he could remember only that her first name was Louise. This baffled us until we happened to review a letter from Burnett Shryock to Fred about the purchase of the *Jefferson* carving, and in that letter Shryock identifies her as Louise Pain, who was a faculty assistant from 1941 to 1944 in the art department.

Our feeling is that, while these pieces may be temporarily lost, they will eventually be found. The reason for this assumption is that the pieces done at this time would have become the property not of the university museum, but of the state of Illinois, and more than likely

89. *Mastodon americanus*
[Catalogue no. 14]. Side view

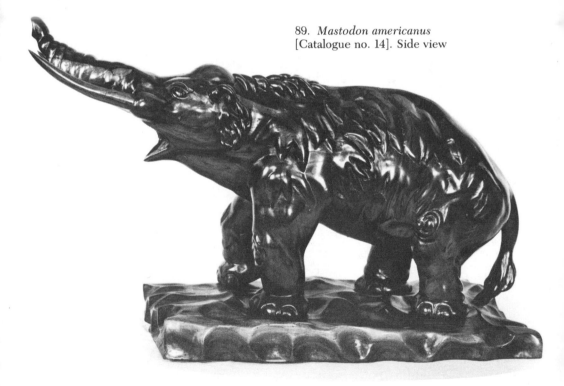

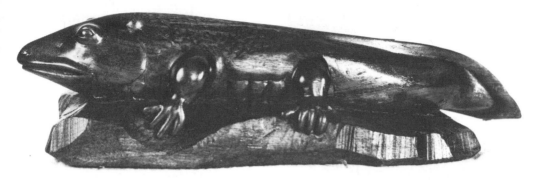

90. *Salamander*
[Catalogue no. 24]. Side view

when the project was liquidated in early 1943 these pieces were dispersed along with thousands of other sculptures, paintings, and crafts. These pieces could conceivably be in public collections anywhere in the United States, and we are convinced that sometime in the near future, maybe because of the publication of this book, they will eventually be catalogued.

Probably our most important discovery reveals just how important luck has been in this research—and how without it, it would have been impossible to find many of the carvings. One of the more valuable pieces was the very last figure Fred worked on before his death. The *Last Stand* was considered by his friends and us as his final testament. The piece was last seen at the Myerses' home in Waltonville, along with other favorite pieces of Fred's, *The Myers Lincoln*, the *Grant on Horseback* and the *Cro-Magnon Bust*. Raymond Myers recalls that two men came to the Waltonville home and requested the partially completed figure, claiming that they intended to finish it based upon Fred's drawings. Raymond was not at home at the time and his wife surrendered the piece. The carving was never seen again and the museum had no record of such a piece. Throughout our search we have been aided by the interest of many people. When they realized what we were trying to accomplish, they generally did what they could to help. Such was the case when we were

given Victor Randolph's name by Julius Swayne. We called and inquired if he knew Fred Myers and in what capacity. In the course of the conversation he mentioned that he had the unfinished *Last Stand*. The rest is now known.

Another incident bears mentioning. Once we were able to date carvings such as the *Grant on Horseback* and the *Jefferson* from the early 1930s, we wondered why the *Jefferson* appeared in the museum collection. It was not done during the time of Fred's tenure with the museum, and, if some other arrangement was made, why didn't it include any of the other pieces as well?

While looking through museum documents during and shortly after that time, we ran across a letter written by Burnett Shryock, then chairman of the Department of Art, who had written to Fred inquiring if the university could purchase his *Jefferson* carving. "Mr. Pulliam would like very much to buy your Thomas Jefferson which he has admired for some time, and has asked me to contact you regarding the sale of it. I, too, think it would be very splendid to have you represented in our collection here at the College and I am writing you to ask the price that you want for it."[8]

The transaction took place and the *Jefferson* became part of the university collection. When the WPA program came to an end, Shryock gained permission from President Roosevelt to keep the collection of art objects that were being exhibited on campus. The *Jefferson* and this gift from the federal government became the nucleus of the art gallery's collection.

We have already recorded what happened to another carving from that period, *The Warren Lincoln*. We are pleased to state at this time that the Warren family has graciously accepted our suggestion to offer the carving to the Southern Illinois University at Carbondale University Museum and Art Galleries as a gift. *The Warren Lincoln* now joins the *Morris Library Lincoln* as part of an already extensive collection.

Probably the most baffling fact about Fred Myers is the absence of specific information about his life. Despite the fact that he only lived to be thirty-nine, everyone we have spoken to, without exception, has commented on what a fine person he was, what deep affection they all shared

for him, and how tragic it was that he died so young. Despite this deep concern and genuine love for the man, specific information about his life is scarce.

His earlier life is recalled, but only scanty facts remain. Many family members are dead and others simply can't remember. We constantly hear the phrase, if we had only known that it would have been important some day. Crucial events like Myers's appendectomy are remembered as fact, but the specifics surrounding the event and even the exact date are lost. The only period that we are certain of in his relatively short life is the WPA years. Here Geno Casagrande has been of great help. There is a dearth of information about Fred during the years between 1942 and 1946. Some of Fred's friends were in the armed services and absent. Raymond Myers who had been so knowledgeable about facts pertaining to Fred's early years was also in service and unhelpful about this period. Those who remained behind claim they didn't see much of Fred because everyone was too busy. More than likely Fred developed some new friends, but who they were has remained a mystery for the most part.

The years from 1946 to his death reveal a little more about the man, but not that much. When Raymond Myers returned from the war he brought with him a new bride and while they remained near the Waltonville home they led separate lives. The Myerses moved to Waltonville and left behind many lifelong friends. Fred's relatively short life in Waltonville, from 1948 to 1950, did not allow him much time to develop new friends. We can be sure, as we have mentioned in our biography, that Fred was not carving very much during these last years. By his own admission, the work at the mines, on the "Hoot Owl" shift (twelve o'clock midnight to seven in the morning) provided adequate income and his own poor health kept him from carving.

It seems apparent that Fred identified with many of the pieces he carved. Surely those that he worked on either before or after his WPA experience were done because of his own strong personal interest in them. Even the WPA experience allowed him time to do the southern Illinois series. It also appears that he had some affection for a number of the prehistoric animals. It is hard to believe that he didn't have a fond-

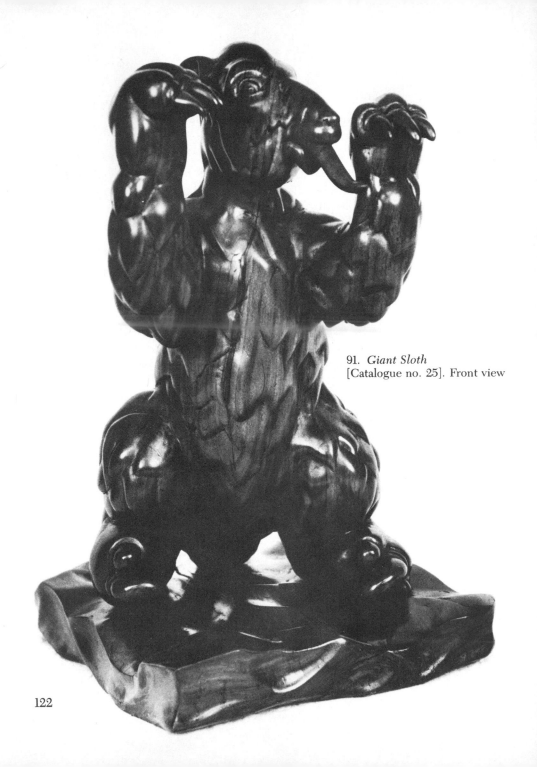

91. *Giant Sloth*
[Catalogue no. 25]. Front view

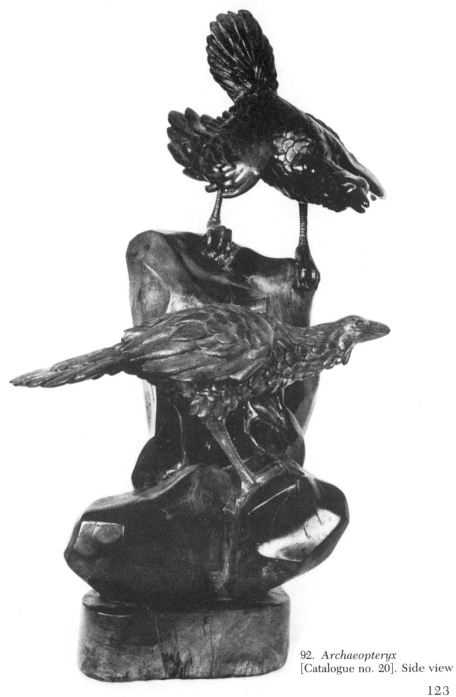

92. *Archaeopteryx*
[Catalogue no. 20]. Side view

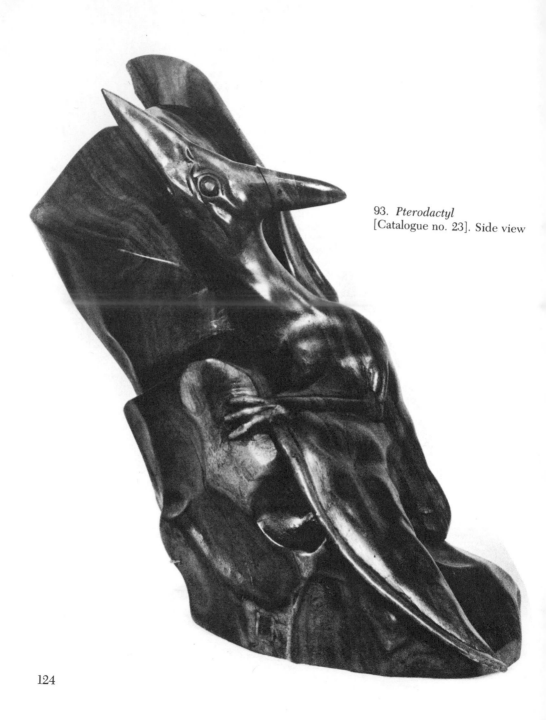

93. *Pterodactyl*
[Catalogue no. 23]. Side view

ness for the *Giant Sloth* with its tongue reaching out to nibble a tempting morsel of greenery. But his general affection for birds, (he did so many quails and was photographed with his carving of a *Crow*), suggest an affection for the *Archaeopteryx*. He seems to have had an exceptional fondness for the *Pterodactyl*. It is possible that he somehow related with the bird's hard struggle up the mountain so that it might obtain a running leap to begin its soaring downward flight. The awkward Sisyphean struggle to climb the mountain is contrasted with the bird's elegant flight. Maybe Fred related his own physical struggle in life as being an uphill battle after the appendectomy, to the contrasted elegance of his sculpture.

This struggle that Fred faced can be dealt with on many levels and can be divided between his own illness and struggles to carve and those struggles that affected the entire family. Of course we are here referring to the struggle to survive during the Great Depression. It seems clear now that Fred's artistic ability could well have been even a bigger benefit to himself and the family if he would have been willing to leave home. The two Chicago job offers come to mind: the one dealt with creating jigs and fixtures from wood and the other as a cartoonist with the *Chicago Daily News*. Two additional jobs were also offered Fred in the Chicago area, but apparently he turned these down as well. He had the opportunity to carve a figure of a dinosaur for the Sinclair Oil Company, and he also had a chance to work for Marshall Fields as a draftsman. The strong attachment to family and friends kept him in the West Frankfort area.

Our interest in Fred Myers and his art resulted in a two-and-one-half-year search to discover the truth about this local southern Illinois woodcarver. Not all the facts about the artist have been uncovered and not all the carvings have been found (fortunately for his art, he evidently produced few such machine lathed objects as the *Candle Holder*), but this book represents an accurate picture of what is now known. The final chapter is yet to be written.

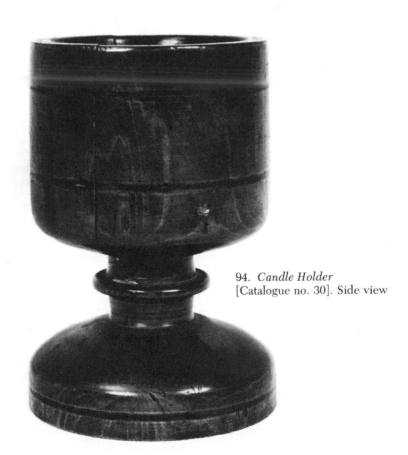

94. *Candle Holder*
[Catalogue no. 30]. Side view

CATALOGUE RAISONNÉ

1. *The Myers Lincoln.* 1929

Walnut. 24¾″ high × 6¼″ long × 9″ deep. Raymond and William Myers Collection, Litchfield Park, Arizona. Shown in photograph 6 by Richard A. Lawson and in photograph 66, courtesy of Rose Pesula Hand. The Rose Pesula Hand negative is in the Raymond and William Myers Collection.

2. *The Warren Lincoln.* 1933

Walnut. 21″ high × 13½″ long × 8½″ deep. Given by the Myers family to Ervin H. Warren in 1957. Donated to the Southern Illinois University at Carbondale University Museum and Art Galleries Collection by Mrs. Ervin H. Warren, Placerville, California. Shown in photograph 7, courtesy of Dan Tetzlaff, Pollock Pines, California, and in photograph 67 by Richard A. Lawson.

3. *Grant on Horseback*. 1935

Walnut. 30⅞″ high × 25⅞″ long × 12½″ deep. Raymond and William Myers Collection, Litchfield Park, Arizona. Shown in photographs 8 and 69 by Richard A. Lawson and in photograph 78, courtesy of Rose Pesula Hand. The Rose Pesula Hand negative is in the Raymond and William Myers Collection.

4. *Crow*. 1935

Walnut. 11″ high × 9½″ long by 14″ deep. Shown in photograph 9. The *Crow* is not extant. The photograph is in the Raymond and William Myers Collection, Litchfield Park, Arizona.

5. *Jefferson*. 1938

Walnut. 24″ high × 10¼″ long × 10¼″ deep. Southern Illinois University at Carbondale University Museum and Art Galleries Collection. Shown in photograph 22 by Richard A. Lawson and in photograph 79, courtesy of Rose Pesula Hand. The Rose Pesula Hand negative is in the Raymond and William Myers Collection, Litchfield Park, Arizona.

6. *Fishing Tackle Box*. 1938

Walnut. 5″ high × 7½″ long × 2¼″ deep. Joseph F. Restivo, Freeman Spur, Illinois. Shown in photographs 40 and 41.

7. *Archer.* 1938

Walnut. 22″ high × 12″ long × 7″ deep. Mr. and Mrs. Frank Tresso, West Frankfort, Illinois. Shown in photograph 63, courtesy of Rose Pesula Hand. The Rose Pesula Hand negative is in the Raymond and William Myers Collection, Litchfield Park, Arizona.

8. *Landscape.* 1937–38

Oil on glass. 16″ long × 10½″ wide. Mr. and Mrs. Al Steyer, West Frankfort, Illinois. Shown in photograph 5.

9. *Beavertail Fore-End.* 1938–40

Walnut. Jack Batts, West Frankfort, Illinois. Shown in photograph 49.

10. *Chair.* 1939–40

Walnut. 11¼″ high × 6¾″ long × 5½″ deep. Mr. and Mrs. Frank Tresso, West Frankfort, Illinois. Shown in photograph 21.

11. *Quail.* 1939

White oak. 3″ high × 2½″ long × 2″ deep. Minnie Amati and Felicia Amati Young, Freeman Spur, Illinois. Shown in photograph 36.

12. *Dinichthys*. 1939

Walnut. 11″ high × 33¼″ long × 1″ deep. Southern Illinois University at Carbondale University Museum and Art Galleries Collection. Shown in photograph 25.

13. *Saber-toothed Tiger*. 1940–41

Walnut. 7″ high × 15″ long × 3″ deep. Photograph not available.

14. *Mastodon americanus*. 1939

Walnut. 18½″ high × 31″ long × 11″ deep. Southern Illinois University at Carbondale University Museum and Art Galleries Collection. Shown in photograph 89.

15. *Eohippus*. 1939

Walnut. 17¾″ high × 20″ long × 14½″ deep. Southern Illinois University at Carbondale University Museum and Art Galleries Collection. Shown in photograph 84.

16. *Mesohippus*. 1939

Walnut. 11″ high × 15″ long × 6″ deep. Southern Illinois University at Carbondale University Museum and Art Galleries Collection. Shown in photograph 85.

17. *Pliohippus*. 1939

Walnut. 14″ high × 12″ long × 5½″ deep. Southern Illinois University at Carbondale University Museum and Art Galleries Collection. Shown in photograph 86.

18. *Equus*. 1939

Walnut. 12½″ high × 12″ long × 5½″ deep. Southern Illinois University at Carbondale University Museum and Art Galleries Collection. Shown in photograph 87.

19. *Modern Horse*. 1939

Walnut. 12½″ high × 12″ long × 5½″ deep. Southern Illinois University at Carbondale University Museum and Art Galleries Collection. Shown in photograph 88.

20. *Archaeopteryx*. 1939–41

Walnut. 30″ high × 19″ long × 17″ deep. Southern Illinois University at Carbondale University Museum and Art Galleries Collection. Shown in photograph 92.

21. *Iguanodon*. 1939–41

Walnut. 22¾" high × 22" long × 10" deep. Southern Illinois University at Carbondale University Museum and Art Galleries Collection. Shown in photograph 76.

22. *Plesiosaurus*. 1939–41

Walnut. 9" high × 22" long × 10" deep. Southern Illinois University at Carbondale University Museum and Art Galleries Collection. Shown in photograph 26.

23. *Pterodactyl*. 1939–41

Walnut. 20" high × 14" long × 9" deep. Southern Illinois University at Carbondale University Museum and Art Galleries Collection. Shown in photograph 93.

24. *Salamander*. 1939–41

Walnut. 4" high × 18" long × 7" deep. Southern Illinois University at Carbondale University Museum and Art Galleries Collection. Shown in photograph 90.

25. *Giant Sloth*. 1939–41

Walnut. 23½″ high × 11½″ long × 14½″ deep. Southern Illinois University at Carbondale University Museum and Art Galleries Collection. Shown in photograph 91.

26. *Stegosaurus*. 1939–41

Walnut. 14″ high × 19½″ long × 6″ deep. Mr. and Mrs. Moreau S. Maxwell, East Lansing, Michigan. Shown in photograph 29.

27. *Trachodon*. 1939–41

Walnut. 20″ high × 37″ long × 10½″ deep. Southern Illinois University at Carbondale University Museum and Art Galleries Collection. Shown in photograph 65.

28. *Triceratops*. 1939–41

Walnut. 10″ high × 23″ long × 8″ deep. Southern Illinois University at Carbondale University Museum and Art Galleries Collection. Shown in photograph 77.

29. *Slave Chained to a Walnut Stump*. 1939–40

Walnut. 14½″ high × 7″ long × 5″ deep. Mrs. Fred R. Cagle, New Orleans, Louisiana. Shown in photograph 28.

30. *Candle Holder*. 1940–41

Walnut. 9″ high × 4″ deep. Raymond and William Myers Collection, Litchfield Park, Arizona. Shown in photograph 94.

31. *Hound*. 1940–41

White oak. 11″ high × 25″ long × 9″ deep. Mr. and Mrs. Moreau S. Maxwell, East Lansing, Michigan. Shown in photograph 82.

32. *Quail*. 1940–41

White oak. 8″ high × 2¾″ long × 3″ deep. Gus Peebles, West Frankfort, Illinois. Shown in photograph 37.

33. *Quail*. 1940–41

White oak. 7″ high × 2¾″ long × 3″ deep. Raymond and William Myers Collection, Litchfield Park, Arizona. Shown in photograph 38.

34. *Gun Rack.* 1940–41

Walnut. 4″ high × 5″ long × 2″ deep. Irene Killian, West Frankfort, Illinois. Shown in photograph 39.

35. *Sketch of a Cowboy.* 1940–42

Pencil. 8½″ × 11″. The sketch was made on the reverse side of the *Sketch of a Glyptodon* drawn by Alyce Pulley for the Southern Illinois Normal University Museum. Raymond and William Myers Collection, Litchfield Park, Arizona. Shown in photograph 83.

36. *Mantel.* 1940–41

Walnut. 47½″ high × 60″ long × 6″ deep. Mr. and Mrs. Frank Tresso, West Frankfort, Illinois. Shown in photograph 64.

37. *Coal Miner.* 1941–42

Walnut. 30″ high × 20″ long × 11″ deep. Southern Illinois University at Carbondale University Museum and Art Galleries Collection. Shown in photograph 70.

38. *Helmsman*. 1942

Walnut. 24″ high × 11″ long × 12″ deep. Southern Illinois University at Carbondale University Museum and Art Galleries Collection. Shown in photograph 62.

39. *Woodsman*. 1942

Walnut. 23″ high × 10″ long × 11½″ deep. Southern Illinois University at Carbondale University Museum and Art Galleries Collection. Shown in photograph 61.

40. *Morris Library Lincoln*. 1942

Walnut. 31″ high × 21½″ long × 14¾″ deep. Southern Illinois University at Carbondale University Museum and Art Galleries Collection. Shown in photograph 68.

41. *Farmer with His Dog*. 1942

Walnut. 30″ high × 20″ long × 13″ deep. Southern Illinois University at Carbondale University Museum and Art Galleries Collection. Shown in photograph 71.

42. *River Rat.* 1942

Walnut. 22″ high × 12″ long × 14″ deep. Southern Illinois University at Carbondale University Museum and Art Galleries Collection. Shown in photograph 32.

43. *Pioneer.* 1942

Walnut. 24″ high × 11½″ long × 10″ deep. Southern Illinois University at Carbondale University Museum and Art Galleries Collection. Shown in photograph 60.

44. *United States Navy Plaque.* 1945–46

Walnut. 12½″ high × 8½″ long × 2″ deep. Mr. and Mrs. Louis Tresso, West Frankfort, Illinois. Shown in photograph 52.

45. *Pipe.* 1945–46

Wild Cherry. 2½″ high × 6″ long × 1½″ deep. Harold Mitchell, West Frankfort, Illinois. Shown in photograph 53.

46. *Pipe*. 1946–47

Wild Cherry. 2½″ high × 6″ long × 1½″ deep. Raymond and William Myers Collection, Litchfield Park, Arizona. The pipe is no longer extant. Shown in photograph 54.

47. *Sketch of a Turk's Head Pipe*. 1946–47

Pencil. 8½″ × 11″. Raymond and William Myers Collection, Litchfield Park, Arizona. Shown in photograph 43.

48. *Turk's Head Pipe*. 1946–47

Wild Cherry. 2½″ high × 6″ long × 1½″ deep. Mr. and Mrs. Kenneth Lazzeri, West Frankfort, Illinois. Shown in photograph 42.

49. *Shotgun Stock*. 1947

Walnut. Gus Peebles, West Frankfort, Illinois. Shown in photograph 50.

50. *Rifle Stock*. 1947–48

Walnut. Louis Ruzich, Plumfield, Illinois. Shown in photograph 51.

51. *Cro-Magnon Bust.* 1948

Walnut. 15″ high × 7½″ long × 7″ deep. Raymond and William Myers Collection, Litchfield Park, Arizona. Shown in photograph 57.

52. *Last Stand.* 1949

Walnut. 37″ high × 27″ long × 15″ deep. Victor Randolph, Carbondale, Illinois. Shown in photographs 58 and 74.

Notes
Bibliography
Index

Notes

Life

1. Batts interview.
2. Victor Randolph, who owns the piece today, refers to it as the *Unfinished Symphony*. Geno Casagrande calls it the *Last Stand*.
3. An article about Fred Myers by James Margedant in the Evansville, Ind., *Sunday Courier and Press*, Apr. 19, 1941, was based on an interview with Fred. It is clear that the coal mining experience was hard on him and his art from 1926 until he quit mining in 1938.
4. Drake interview.
5. Hastings, *A Nickel's Worth of Skim Milk*, p. 70.
6. Harold Mitchell relates the story, but no one actually saw Fred in the tuxedo.
7. Myers interview.
8. Hand interview.
9. Batts interview.
10. Maxwell interview.
11. The Myers family purchased six acres from Dan Bellini and fourteen from Dan's father Arturo, who was living in Texas.
12. This fact is substantiated by the Deasons, Harold Mitchell, Frank Tresso, and Raymond Myers.
13. Lazzeri interview.
14. Ibid.
15. Myers interview.
16. A quote from Fred Myers given in the Evansville, Ind., *Sunday Courier and Press*, Apr. 19, 1941.
17. Maxwell interview.
18. Ibid.

19. See Catalogue Raisonné for complete listing of works.

20. Numerous pieces of correspondence between President Pulliam and Fred Cagle can be found in the special documents section of Morris Library, Southern Illinois University at Carbondale.

21. Lendell Cockrum is now chairman of the Department of Biology at the University of Arizona, Tucson, and Moreau Maxwell is professor of anthropology at Michigan State University, East Lansing.

22. Cagle letter to Pulliam.

23. Maxwell interview.

24. Ibid.

25. Thorpe letter to Pesula [Hand].

26. *Archaeopteryx*; *Brontosaurus* (missing); *Coal Miner*; *Dinichthys*; *Farmer with His Dog*; *Fisherman with Boat and Oar* (missing); *Giant Sloth*; *Glyptodon* (missing); *Helmsman*; Horses: *Eohippus, Mesohippus, Pliohippus, Equus,* and *Modern Horse*; *Mastodon americanus*; *Morris Library Lincoln*; *Pioneer*; *Plesiosaurus*; *Pterodactyl*; *River Rat*; *Saber-toothed Tiger*; *Salamander*; *Standing Indian* (missing); *Stegosaurus*; *Trachodon*; *Triceratops*; and *Woodsman*.

27. Batts interview.

28. Ibid.

29. This blues number was composed by Richard M. Jones in 1926. The lyrics, which deal with the blues, solitude, and release from pain through death, no doubt had some special meaning for Fred.

30. Randolph letter to Myers.

31. Victor Randolph suggests that Dr. Fox may have been familiar with Fred's case through the Myerses family doctor, A. W. Modert.

32. Deason interview.

Art

1. Benton, *An American in Art*, p. 151.

2. A term used by Benton in *An American in Art*, p. 161.

3. Ibid., p. 150.

4. Benton, *An Artist in America*, p. 315.

5. Casagrande interview.

6. Hand interview.

7. Benton, *An American in Art*, pp. 46–48.

8. Batts interview.

9. Ibid.
10. Ibid.
11. Hand interview.
12. Craven, *Men of Art*, p. 508.
13. Benton, *An Artist in America*, p. 342.

The Search

1. Lazzeri interview.
2. Casagrande interview.
3. Maxwell interview.
4. Batts interview.
5. Casagrande interview.
6. Randolph interview.
7. Barton letter to Pulliam.
8. Shryock letter to Myers.

Bibliography

Books

Benton, Thomas Hart. *An American in Art*. Lawrence: University Press of Kansas, 1969.

―――. *An Artist in America*. 1937. Reprint ed. Columbia: University of Missouri Press, 1968.

Craven, Thomas. *Men of Art*. New York: Simon and Schuster, 1931.

Hastings, Robert. *A Nickel's Worth of Skim Milk*. Carbondale: University Graphics and Publications, Southern Illinois University at Carbondale, 1972.

Interviews

Batts, Jack. At West Frankfort, Ill., Jan. 16, 1979, taped.

Benton, Thomas Hart. Interviewed by Robert Randall, at Kansas City, Mo., spring 1974, taped.

Casagrande, Geno. At Benton, Ill., July 17, 1978, and at Carbondale, Ill., Sept. 5, 1978, taped.

Deason, Howard. At Plumfield, Ill., Oct. 7, 1978, untaped.

Drake, Walter. At West Frankfort, Ill., Apr. 17, 1979, untaped.

Hand, Rose Pesula. Written interview to George J. Mavigliano, Apr. 5, 1979.

Kownacki, Edward, and Swayne, Julius. At Rend Lake College, Ina, Ill., Feb. 13, 1979, taped.

Lazzeri, Kenneth. At West Frankfort, Ill., May 1, 1979, taped.

Maxwell, Moreau S. At East Lansing, Mich., Mar. 12, 1979, taped.

Myers, Raymond. At Miller's Lake, near Mount Vernon, Ill., July 10, 1978, taped.

Randolph, Victor. At Carbondale, Ill., May 9, 1979, taped.

Swayne, Julius. Telephone interview, Feb. 6, 1979, untaped.

Newspapers

"Area Coal Miner, Who Died at 38, Leaves Wood Carvings as SIU Art." *Daily Egyptian* (Carbondale: Southern Ill. Univ.), Mar. 12, 1964, p. 2.

Brundage, Jack. "Art Exhibition for Egyptians Held Success." *Southern Illinoisan* (Carbondale), Dec. 2, 1947.

Chicago Daily News, Feb. 27, 1941, p. 28.

"Coal Miner's Wood Carvings on Display." *Daily American* (West Frankfort, Ill.), Mar. 12, 1964, p. 8.

Daily American (West Frankfort, Ill.), Apr. 8, 1972.

Donnelly, Ed. "Fred Meyers Was a Self-Taught Sculptor." *Daily Egyptian* (Carbondale: Southern Ill. Univ.), Nov. 20, 1971, pp. 6–7.

Egyptian (Carbondale: Southern Ill. Normal Univ.), Oct. 9, 1947, p. 3.

"Fred Myer Stops Wood Work." *Southern Illinoisan* (Carbondale), June 14, 1948.

"From Coal Miner to Wood Sculptor." *St. Louis Post-Dispatch*, Apr. 20, 1941.

McClintock, Jack. "Fred Myers Was an Unusual Man." *Daily Egyptian* (Carbondale: Southern Ill. Univ.), Feb. 26, 1966, p. 5.

"Many Knew Myers for Work in Wood." *Daily American* (West Frankfort, Ill.), Mar. 13, 1964.

Margedant, James. "Chips Off the Old Block Bring Fame to Coal Miner." *Sun-*

day Courier and Press (Evansville, Ind.), Apr. 19, 1941, Sec. D, Fine Arts.

Morani, Caesar, Jr. "Artist with a Hatchet, Chisel, Knife." *Benton Evening News* (Benton, Ill.), Nov. 2, 1977, p. 10.

————. "Work He Loved Had Role in Artist's Death." *Benton Evening News* (Benton, Ill.), Nov. 3, 1977, p. 12.

Philadelphia Inquirer, Sept. 14, 1941, p. 5.

"Work of Miner-Artist." *Register-News* (Mount Vernon, Ill.), Mar. 12, 1964, p. 9.

Other

Barton, Thomas F. Letters to Richard A. Lawson, Jan. 8, 1980, and Jan. 31, 1980.

————. Letter to Roscoe Pulliam, Aug. 30, 1940. Roscoe Pulliam Papers, Morris Library, Southern Illinois University at Carbondale.

Cagle, Fred. Letter to Roscoe Pulliam, Sept. 26, 1940. Roscoe Pulliam Papers, Morris Library, Southern Illinois University at Carbondale.

"It's Happening in Southern Illinois." News release, University News Service, Southern Illinois University at Carbondale, Sept. 23, 1971, pp. 1–3.

News release. University News Service, Southern Illinois University at Carbondale, Feb. 2, 1972, pp. 1–2.

Randolph, Victor. Letter to Fred Myers, June 19, 1948. Raymond and William Myers Collection, Litchfield Park, Arizona.

Shryock, Burnett H. Letter to Fred Myers, Dec. 8, 1943. Roscoe Pulliam Papers, Morris Library, Southern Illinois University at Carbondale.

Thorpe, George. Letter to Rose Pesula [Hand], Sept. 12, 1938. Raymond and William Myers Collection, Litchfield Park, Arizona.

Index